MY BODY IS YOURS

MY
BODY
IS
a memoir
YOURS

MICHAEL V. SMITH

ARSENAL PULP PRESS VANCOUVER

ARSENAL PULP PRESS
Suite 202–211 East Georgia St.
Vancouver, BC V6A 1Z6
Canada
arsenalpulp.com

The publisher gratefully acknowledges the support of the Canada Council
for the Arts and the British Columbia Arts Council for its publishing
program, and the Government of Canada (through the Canada Book
Fund) and the Government of British Columbia (through the Book
Publishing Tax Credit Program) for its publishing activities.

Cover photograph: David Ellingsen
Book design by Gerilee McBride
Editing by Susan Safyan

Printed and bound in Canada

Library and Archives Canada Cataloguing in Publication:

Smith, Michael V., author
My body is yours : a memoir / Michael V. Smith.

Issued in print and electronic formats.
ISBN 978-1-55152-577-8 (pbk.).—ISBN 978-1-55152-578-5 (epub)

1. Smith, Michael V. 2. Authors, Canadian (English)—21st
century—Biography. 3. Artists—Canada—Biography. I. Title.

PS8587.M5636Z53 2015 C813'.6 C2015-900403-9

C2015-900404-7

MIX
Paper from
responsible sources
FSC
www.fsc.org
FSC® C103214

for Jim Deva, a national hero,
Stephen Harper, the antithesis,
and my father, a man.

In the dark folds of time maybe there's nothing except the dumb touch of our fingers.

And our deeds.

—John Berger, *From A to X*

Abreaction: the expression and consequent release of a previously repressed emotion, achieved through reliving the experience that caused it.

—*Oxford American Dictionary*

CONTENTS

SILENCE AND THREAT: AN INTRODUCTION

I SPENT THE FIRST thirty years of my life trying to disappear.

My body betrayed me. When I was a small, slim shaggy-haired boy in middle school, a friend's mother told me every time she saw me, in her hardened gravelly voice—usually while turning blood sausages on the stove—that I was a handsome boy, yes, but I would make a *beau*tiful girl.

She wasn't alone. Until I reached puberty, everyone mistook me for a girl. My voice was high-pitched, my hair was long—it was the 1970s—and my eyelashes were like butterfly wings. I was the skinniest kid anyone had ever laid eyes on. I used big adjectives I'd learned watching Phil Donahue. I was soft.

For five or six years of my young life, I wanted simple, obvious things: to have a different voice, a different body, different hair, different clothes, different parents, a different home. I clenched my little fingers together at night under Star Wars sheets and prayed to a random god to make me someone else. I prayed to be hairy. I prayed for my voice to drop. I prayed for my father to stop drinking and for my mother to calm down and love me. I prayed for friends. I prayed for money. I prayed for invisibility, and I prayed to be seen.

I think I survived for as long as I did because, without knowing it, I had that magical skill that young people in dire situations need: a simple naïve ability to hope that my prayers could be answered if I clung to them long enough. Or maybe that's half the answer. I somehow understood that hope put into practice was hope granted. Hope was work. And I worked long and hard. Not at making a new body, mind you, or faking it better, but at making myself into who I wanted to be—which was a convoluted way of allowing myself to be who I was— despite the accidental and deliberate shit slung at me. I think Donahue taught me that too.

My prayers to be different could only be answered by making one small, instinctive decision at a time. Contrary to my suicidal daydreams, I didn't throw myself out of my bedroom window, I didn't run into oncoming traffic in the street, I didn't take any of the pills in the medicine cabinet. I grew up.

In 1981, I had a significant "first" in my life, a brief affair with a sexual bully. It was the year "Bette Davis Eyes" by the smoky-throated Kim Carnes was the number-one song, Prince Charles married Lady Di, Nintendo introduced North America to Mario in Donkey Kong, and The Centers for Disease Control and Prevention in the US announced that five gay men in L.A. had a rare pneumonia.

That first boy I fooled around with had the word "evil" in his name. To mark the spirit of the times, let's call him Knievel, after the motorcycle daredevil Evel Knievel, listed in the *Guinness Book of World Records* for "most broken bones in a

lifetime." Evel was all over the TV in the early '80s, jumping over buses and shark tanks. For a birthday present that year I was given his action figure with a pull-cord-powered motorcycle. I was a not-yet-queer kid. A stunt jumper in white leather was hot shit. He had no fear too great to challenge.

The Knievel in my class seemed just as reckless. I was ten in '81, in grade five at Sydney Street Public School, three blocks from our small World War I era home. Knievel was two years older than me, but only a grade ahead, because he'd failed grade one or two. Sydney Street Public was a small school, so grades shared a room; we had Mr Thompson, the aging bachelor principal. I don't remember Knievel having any friends, partly because he transferred into the school late, in grade four, I think, and partly because he was a bad mix of aggression and unpredictability. In hindsight, I think he was more hyper than violent, but as a young fey kid, it was hard for me to discern the difference.

On the day for class photos, when we'd line up in the gymnasium shortest to tallest, I was in the first half, at around the one-third mark, usually standing behind Julie Legue and ahead of Jennifer Khalil. My position in class line-ups was a synecdoche for the playground, where I always sandwiched myself between the girls. Hopscotch, skipping, marbles, patty-cake, and swing sets were the safe games on the school ground. Because I was a limp-wrister, the boys never wanted me on any of their lunch-hour sports teams. So when Knievel's busy eye settled on me one day—he invited me over after school—I swallowed my fear and said yes.

My father worked in the warehouse for Sovereign at the time, a mail-order distributor. My mother had been responsible for Sovereign's Human Resources; she'd done the hiring and firing. This was the best job she would have in Cornwall, at the age of thirty-one. After Sovereign let my mother go in '79, then went belly up during a long mail strike in the early '80s, the cycle of layoffs for my parents began, as they moved from jobs in one mill to another. Dad would be out of work for long stretches at a time. My sister and I joined the kids at school lucky enough to go home at lunchtime for a hot meal. Dad prepared either soup and sandwiches or Kraft Dinner and hot dogs. The table would be set before we walked in the back door.

This was all before my parents' first separation. If my father was working, he'd return drunk on payday Thursday, much too late for supper and with little of the paycheque left, to find the door dead-bolted. Because my father was an alcoholic and my mother was a screaming hysteric in response, I had learned to compartmentalize, to slide opaque walls around what happened at the breakfast table so I wouldn't have to look at it for the rest of the day—or ever. A lot of my childhood landscape was like a shipyard of storage containers, the days stacked and invisible, one row against another. This was our normal. Silence and threat.

In the quiet aftermath at the end of a day, I'd lie in bed imagining ways to escape, sometimes jumping out the second-storey window or using my Star Wars sheets to lower myself down. Sometimes I'd slip to my death; sometimes I'd jump head first on purpose. Or I'd run down the steps and out the front door

into traffic. I'd time it for when a transport truck was passing, to be thorough.

When I was seven, our neighbour Pat had been driving her son Scott home when she was stopped at the streetlight at Seventh and Sydney. By an ugly alignment, Pat witnessed a transport trailer back over a young girl coming home from school, just blocks from our house. She saw the large wheel catch the girl's leg, watched her fall in a second, and then the massive truck tire roll over the girl's head. Pat had clutched her son's face to her chest so he wouldn't see. That event was in my imagination. Thirty-five years later, the images I created from Pat's story (some of which came from Scott, who overheard details that are too grisly to revisit) are still vivid. I knew what a transport could do, and do quickly. Prone on my bed, I'd imagine my death could be quick like that.

Often I would fabricate a way to live in the tall grasses in the open field across from our house. Or I'd imagine hitchhiking or walking all the way to my grandparents' house, an hour's drive away, and they'd take me in. They'd hide me.

I lived a great deal of my early childhood feeling like I was alone at the bottom of a deep well, shouting upwards, with nobody bothering to peer over the lip and help. I once lay with my ear to the upstairs open hot-air vent to overhear my parents discussing how they couldn't handle me anymore. My mother suggested they send me away to boarding school, my father countered that we couldn't afford it, and a floor above them, I reeled with the fear that I would be even more isolated in the world.

So when Knievel invited me home after school that day, I felt like he'd thrown down a rope.

A block and a half away from our tumbledown house, Knievel lived with his maternal grandparents in a corner-lot 1950s bungalow amongst a neighbourhood of mostly small wartime houses, built in the 1910s. When I knocked, he opened the door. A girl stood just behind him. He introduced me to Lee, his sister, whom I wasn't expecting. Lee's plain brown hair fell straight to her shoulders, and her bangs dangled in her eyes, which were the same kaleidoscopic blue as her brother's, but without the wildness.

The two of them had had their last name changed to match that of their grandparents after they'd moved in with them. I vaguely remember being told by someone that they'd had trouble with their parents so they'd been taken away. Their grandfather worked at the paper mill; he had the income to raise grandkids.

Knievel and Lee brought me downstairs—I didn't meet their grandparents on that first visit—to play a game of hide-and-seek in the unfinished basement with the lights off. There was a workbench and stacks of boxes, car tires, old bikes, remnants of a wood project, and machinery of one kind or another stored down there. We played in the pitch dark. We had to step through the blackness to hide somewhere, which left me barely able to move. The dark had long been one of my terrible fears. Breathing as quietly as possible, I crawled on all fours across the cement, carefully placing my hands ahead of me so I wouldn't bump into anything.

Knievel finished counting to forty. Then there was such a silence in the darkness, I couldn't determine if he was moving until he was within two feet of me. I tried to be still, to be rock, inanimate, so that he'd pass by me, but he bumped my leg and knew it was flesh. As the first one caught, I was "it" for the next round.

I tried, but after counting to forty, I couldn't move. The door to the basement was shut tight and two bodies were hiding somewhere in the blackness, one of whom felt dangerous. I couldn't take a step. My fear was far greater than my pride, so I spoke into the blackness. "I can't find you. I don't want to play this anymore."

There was silence. Only when I admitted that I was too scared to play could I coax them to come out.

Their alternative was to play another game in the fort Knievel had built along a wall in the basement. I'm not sure what it rested on, but the fort was a few feet off the ground and enclosed by walls on all sides. A wooden door slid back to reveal a carpeted space about the length and depth of a closet, but only three feet high, just tall enough for us to sit with a small clearance above our heads. There was a desk lamp in a corner that Knievel turned on. All three of us piled in, and Knievel slid the door closed.

For this second game Knievel and his sister said we were to take off our clothes. They gave me a moment to absorb that, and as I hesitated, his grandmother's footsteps creaked on the hardwood above us.

I said I couldn't, then Knievel looked me in the eye and said calmly, "I won't be your friend unless you do." Most everything

about that moment has stuck with me—the ultimatum, my stomach turning with nerves, the intensity of his blue eyes, and his quiet, clear tone of voice which said this was true, that I could be cut out so easily.

With our clothes off, the game was to take turns directing a mix and match of body parts: Michael puts his nose in Lee's belly button, her arm on his leg, a foot on a bum. Knievel and I took turns paired with Lee. It was equitable, in that we did rounds of choosing, so that Lee got to pick who and what. We stayed loyal to the gender mix, strict boy and girl. As we went round, the dares grew more intimate or bizarre. Long hair dangled in a butt crack, lips were placed on an ear, a finger in a mouth.

We played for an hour or more. On my turns, I took long pauses, not so much trying to decide what to do but what I could bring myself to speak aloud. Finally, I had to be home for supper and we dressed. Knievel told me not to tell anyone, and there was some threat I've now forgotten—he'd beat me up or lie and say it wasn't true—but the threat wasn't necessary to keep me quiet.

I don't remember much of the time that followed, though I've a clear recollection of my nerves. I was sick to my stomach with fear for what we'd done. Never had I kept such a secret from my parents. I was accustomed to keeping private our lives at home, monstrous with fights. But in those secrets my parents had been accomplices. This secret was mine and Knievel's and Lee's, and nobody else's. This was when I began to build a great privacy from my parents.

The second time we played this game, Knievel and I were alone. I knew what to expect this time, so the thrill of the experience was lessened until I suggested the pairing of body parts that made him uncomfortable. For me, our measure of success was how much it could make our stomachs flip and flutter. If it didn't churn our insides as it had the first time, it wasn't worth doing. I'm not sure what, but I suspect Knievel had something else in mind; he was more timid with me alone. He didn't like the tables being turned, where I was comfortable pressing the game forward. At one point he insisted we stop, but my curiosity wasn't satiated and I pulled out the best threat I had. "I'll tell your grandmother," I said.

When Knievel agreed to continue, I felt a rush of heat run down my arms and legs. We positioned ourselves in more combinations; he resisted every other suggestion. We had a push and pull on each one; some I managed to talk him into, others he flat-out refused. In hindsight, it was all pretty innocent, given that neither of us were sporting erections yet.

We stopped at about the moment I ran up against my own level of discomfort. We had exhausted the body parts I felt drawn to pairing—I wasn't yet interested in anything penetrative—so we reached a point where there was no need to continue. I left that day with an odd sense of trembling in my body, a kind of wave. The knowledge that I had managed to humble the wild Knievel worked on my psyche like a low electric current. I had possessed the power to change a boy's behaviour.

A week or so later, Knievel turned up in my yard to play. Being at his place was fine, but on my own home ground, he

proved to be too great a threat. He was too loose with my body that afternoon, running after me, tackling, picking me up. Partly because he knew what we had done (he could expose me, we could be found out) and partly because he was too wound up to be aware of how people perceived him, Knievel was dangerous. Careless.

At one point he chased me around my back yard, growling. I'd asked him to stop, but he continued. As he pursued me around our swing-set, I threw a seat behind me, very deliberately smashing him in the chest. My mother saw us and intervened, scolding me. Because my fear of being caught by my parents outweighed my interest in continuing the game, that incident put an end to hanging out with Knievel. I ignored his invitations after that, telling my parents he was too rough and mean.

I have carried this dark sexual mystery—bodies that whisper in uncertain, potentially threatening circumstances, playing with power, trading a sort of shared secrecy, aware of the strangeness of another, the strangeness of intimacy, the release and abandonment that accompanies coercion—into the most charged sexual moments in my adult life. Being with Knievel is how I learned to be vulnerable, to give in, to open my hand and release caution, trusting that the heat of the moment would be greater than the risk. The kiss I gave my first boyfriend in the back seat of his mother's Malibu when we were still virgins began in that same silence, that hush of uncertainty, pushing

shame and a fear of the unknown aside to release the heat running circles in my loins. It was there when I slipped my mouth around his dick the first time. The hush followed me, or I followed it, hunting an intensity that doesn't show itself when you speak too loudly or too much.

For the six years after I broke up with that first boyfriend (we were together from the ages of seventeen to twenty-one, with gorgeous years of sex in there), I was more than satisfied swapping blowjobs with random hookups or occasional butt sex with condoms. Then in 1998, my buddy Brad shepherded me to San Francisco, like in a cheesy gay movie. He was a nurse, a decade older than me, who had lived on the West Coast some twenty years more than me. He knew things. We stayed at Beck's Motor Lodge on Market Street, a three-storey motel notorious as a Castro cruising spot.

Every guest was male, except one wife in a Midwestern couple who may have known they were in San Fran but didn't know where they were. Many of the other guests left their doors ajar and sat on their beds, hands strategically placed on their laps, watching a slow trickle of men pass by. Throughout the weekend, a number of guys stood in the doorways to their suites wearing a small white towel, or less.

Within minutes of arriving, Brad and I passed our motel neighbour on the walkway. James looked to be in his early forties. He had a thick moustache and was half a foot shorter than me but easily had fifty pounds more muscle on him. James had the look of a good vintage porn star, with sweet blue-collar manners. He was famous in California, he said, for being the

first out homo police officer, though I can't remember in which city.

After meeting him that first day, I was brushing my teeth in the bathroom when I heard the shower start up on the other side of the wall. At the thought of him lathering his body, my knees practically buckled. We had two more small chitchats, then James invited me to his room to "hang out." Although I couldn't believe my good luck, I was too insecure, and considered not going. Brad wouldn't let me turn down the offer. "You just walk next door and knock. That's all you have to do," he coached. "The rest takes care of itself."

He was right. I knocked, James answered, and he invited me in. Fag life can be that easy.

Through a series of odd steps in which I didn't quite understand what was happening, James orchestrated a white towel on the bed, both of us naked, me lying on my belly, he on top, and his large fat dick slicked up and pressed hard at the button of my ass. Within moments of my arriving, he was trying to wiggle his thick meat in my butt, bare.

I asked him over my shoulder if he wanted a condom. I had some in the pocket of my jeans, on the floor by the wall. I had only ever barebacked with my monogamous first boyfriend; it's easier to stay HIV-negative if you're really good at (and really into) blowjobs.

James asked quietly, "What?" hoping I wouldn't repeat myself. It was everything I could do to ask again, but I did.

He whispered in my ear, "We're only cuddling, Mikey. We're just going to cuddle." But still he played his dick at the entrance

of my butt, pressing and shifting his hips slowly side to side, until the head was definitely stretching my ring of muscle. That's a sensation you never mistake, and not with a dick as thick as his.

We played that loop a few times, where I suggested a condom and he shushed me, insisting we were just cuddling, wiggling his hips ever closer, until the fur of his pubes met the fur of my ass. He was buried to the base, breathing in my ear and whispering how much he liked cuddling me. There was so much repetition of that breathy language, I was sure he was playing out some old history. I was a lucky geek filling in part of a story he felt compelled to re-enact.

The edgy heat in my gut from knowing I was barebacking made me cum within seconds. And James, saying he was disappointed in me, pulled out. Let's skip the rest, where he popped sleeping pills and for the next hour I tried to seduce him, to win him back, while he slept or pretended to sleep (he had so much pretending going on I couldn't tell what was real), until I nearly slipped my dick in his ass and he jumped awake/feigned waking, and I slunk back to my bed next door, wondering whether or not I had nearly raped a man in his sleep. As with most one-night-stands, the denouement was anti-climactic and loaded.

I knew afterwards that I had wanted him to want me badly enough to overlook the risk in barebacking. The hushing in that whole exchange was as hot as it had been with Knievel. I wasn't after James in my ass so much as I was after the feeling he gave me of being invited into a deeply private, illicit experience.

We shared an intense togetherness in secrecy. With his dick hard and slick along the lips of my hole, I had been negotiating with him on the edge of a desire that was dangerous, where neither of us wanted to speak in the dark, working us into a complicity of risk, where desire trumped fear and silence trumped speaking.

In the cruising park after the sun has set, as the moon drops diamonds of white-blue light through the tree cover, the men aren't talking. They wade through the dark with gestures, responding to a touch with another of their own. (For those men who choose to date first, then fuck, the bedrooms of gay dating aren't much chattier.) Many of these men are straight. They call themselves straight; they have women partners. They're married or engaged or have a girlfriend or, occasionally, are between girlfriends. They live a straight public life, suck dick on the side, and for all appearances outside of the quiet moments they have with other men in a dark place, nobody would know any different. What they do in their private time doesn't affect their sense of being straight—they have all the social privilege and get to eat their cake too. What you do for sex in the twenty-first century doesn't influence your identity— it's how you act in public that matters. What you self-name. That's true for these straight men who fuck man ass as much as it is for the fourteen-year-old who comes out without ever having touched a dick other than his own.

I know a great deal about the sex lives of straight men because I've slept with a large number of them. Yes, some wish they

were more straight, some are happy being just this straight, and many will tell you they are decidedly straight, but they "like dick too." Few—very, very few, next to none—ever tell their partners they are screwing men on the side. Just as many of them try to have unsafe sex as the fags I've been with. Maybe more.

I've given or taken a dick in either an upper or lower hole with more than a couple thousand men. I think. I stopped counting when I reached around 1,500. It's all hubris after that. In the last ten years, most of these men barebacked, or tried to. Seventy-five percent, I'd hazard a guess, gay or straight, have tried to stick it in me or get it slipped in them without protection. They say they don't want to, but when you get them alone in a quiet spot and someone's cock is in the crack of someone's ass, they nearly always forget their best intentions. I've had enough sex to know with some confidence that my ass and dick are appealing for a wide range of men, but I'm not so deluded I believe I'm anywhere near the kind of god that would be worth risking an STI to have me raw for half an hour. So the high rate of men who want it bare isn't about how hot I am.

I met these men in bars, public parks, beaches, bathrooms, peep shows, porn theatres, sex clubs, bathhouses, and a wide collection of homes, including mine, in many cities in North America and a modest few in Europe. If we weren't cruising in public, we met via social media, via chat-based websites or apps, which is a new private kind of public. I was dating before Grindr, before gay.com, before backrooms disappeared from most of the gay clubs in Toronto and San Francisco and New York.

I've always cruised looking for safe sex. I nearly always advertised that on my profile. Before meeting, I was clear that I wasn't into bare. If a dick started to worm itself into a butt, we'd need a rubber to proceed. Nearly all of the men I've landed tried to carry through bare, regardless. Most of them didn't bother asking my status. When I asked them, most said they were negative. They assumed I must be neg too—or why would I be barebacking? The rest, who said they were pos, assumed I was too, for the same reason.

At my cruising best, I'd have a conversation. Say hello, get a name. I'd give my name and shake a hand before either of us dropped to our knees. At my cruising best, we sat on a couch and talked about any old thing you might shoot the shit about with a buddy you run into on a sunny day in front of a café. At my cruising best, I laid out clearly that I didn't bareback and that I was negative. On my best nights, I asked their status and whether they wanted it bare or not, before starting. I am much more forthcoming than nearly all of the thousands of men I've fooled around with; I'm much more likely to speak. And still, I was at my cruising best only about twice a year.

I used to think my past with Knievel had caused my sexual history of putting myself in the path of danger. The notion that a past event makes us the people we are today teaches us to think we are victims of our histories, rather than of the narratives we build up around them. I could have told myself a different story about James the cop. I could have framed our barebacking differently. But I didn't. For a good dozen years after that incident, I would replay the cop's hot breathy voice

while I jerked off saying those words, *We're just cuddling*, and cum in a heartbeat. I cultivated the memory; I planted it in the soiled loins of my psyche. The cuddling cop carried all of the best qualities of a great sexual moment for a gay man. Most of us—the generation who lived our early years in the closet with the threat of AIDS in news reports, all those deaths and protests—know the silence James was rocking us toward.

After that moment with James, I often lacked perspective on the consequences of being penetrated without a condom, though only while it was happening. With a raw dick in my ass, there was no tomorrow. The unfettered sexual ecstasy was the ultimate sign of success. I was at the zenith of intensity, which was a kind of darkness without memory, and so the intensity knew nothing of regret. If the sexual alchemy was correct, I conquered silence, I transcended fear.

It was another echo to those moments with Knievel. The heart-racing thrill I sought out in my early days of sexual exploration was still what I sought as an adult, only the stakes needed to be raised. What I wanted with Knievel was the same needy, make-me-feel-worthy aliveness that allowed a cop's raw dick into my ass. And a few dozen after him. Believing that I was less of a man made another man wanting me more valuable.

It was not my past with Knievel and a California cop that might have seen me gracefully bareback and risk contracting HIV, but a sense of being empty-handed, of looking forward without company. The things we longed for in our first moments of sexual awakening and practice are those that we

fumble toward in our adult lives. It was not an event that was a root cause of any pattern in my behaviour, but the desire behind it. Pursuing longing—an unanswerable need—is always about chasing the future. It always has consequences.

Everything we don't say in the privacy of our sex lives builds room for permission, a permission of neglect, which thrills. It is the thrill of potential danger, of being caught or found out or getting away with something, the thrill of being able to project onto that clean white slate who I want the other man to be, the thrill of walking a line between identities. I am often, in a sexual moment, trying to find the edge of a desire that is ver-boten, one in which neither of us dare speak aloud in the dark, working us into a shared risk. If I'm not doing that work, the other guy is.

Our silence is an echo. We came of age not speaking. The hush was there before we began to shave, in our confusingly clear dreams, watching the knuckles and biceps of our friends' dads, in the sleepovers of temptation, tackled on the play-ground, and jostled on the bumpy school bus. We learned what was hot in secrecy, so that, as easy as smoke, secrecy seeped into the fabric of that desire. Secrecy became no longer just a useful veil over how we did this or that; secrecy was the thing we desired. We preferred to slip on the worn old clothing of silence—which was gendered, a man's garment—to find either intimacy or an illusion of it.

In *The Queer Art of Failure,* Judith (Jack) Halberstam writes that being "negative, unsuccessful, ruinous, and forgetful are a

means to undo, to unknow, to unbecome what the conservative world has tried to make of you." This book is a chronicle of my queer failures, which have been hard won.

Of course I'd like to brag about how I turned the tables on my bully, Knievel, to show how clever I was to empower myself, but that perspective belies the shame I then felt for removing my clothes, for touching a brother and sister in the dark, for being taken advantage of. Such moments of shame may be common in children, but without that knowledge, the shame filled my insides with a wasps' nest of worry. That experience, and my failure as a boy, made for a profound disconnect within my body, created a fear of my own desire and a fear of being seen—by my parents, by strangers on the street, by Knievel, who recognized something in me that he could use. And I admit that I claimed power at Knievel's expense, from a kid who (I now assume) was abused. Because I too became a bully—perhaps a crueller one than Knievel, because I threatened exposure where he threatened only to withdraw a friendship—my triumph made the moment a triple fail.

If Halberstam is correct that queer failure can offer its own reward, if a failed boy can reach into the swamp and draw out a key, mine was shame and the dark knowledge it opened within me.

THE BOY WHO WOULD NOT BE

SYDNEY STREET PUBLIC didn't have middle school, so for grade seven I started at Central Public in downtown Cornwall. It was one of the oldest schools left in the city, with newer boxy wings added on to the sides. I was so nervous the night before I started that I had what my parents and I thought was the flu. That sick feeling of chills, near fainting, and my stomach rolling over like a shoe in a washing machine would follow me into later life. It was a fever of anxiety.

My parents had me lie on the couch in the living room while they watched *Porky's* on TV. The young men saying words I'd never heard were a small distraction from the bucket my mother placed next to the couch. I felt like I might throw up at any moment. Every guy in the film who wanted a blowjob more than a girlfriend didn't help, but I remember the young men were something of an awakening, even if I didn't understand much of what they were talking about.

Within the first few days of being at Central, I met the first great love of my life, Dana. Standing on the pavement of the school grounds, he showed the other kids how he could flip his

lower eyelids inside out, rest his square, silver-framed glasses on those lids, draw in his chin so it was buried in his neck, then speak in a funny voice. His impression looked like Beaker from the Muppets. My first thought was, *Here's someone who'll be my friend.*

Dana was great company. The first time I visited his home, a giant four-bedroom doctor's house on a large corner lot, he put Jane Siberry's *Speckless Sky* album on the record player. Then Falco, then Prince. He could play every instrument under the sun. To honour Wham!, we recorded our own Weird Al-type song, "Bake Me Up Like a Pogo." He tried to teach me drums and break dancing. We watched *The Outsiders* lying on the white shag carpet in his TV room and sobbed together at the end. Sitting on the piano bench next to him, I learned the opening bars to the theme of *Phantom of the Opera*, which is the only piano I've ever learned. I can play that bit to this day.

My parents separated—though it was short-lived—when I was in grade seven. After years of screaming and dish-throwing and pouring beer down the sink, we sold our home, and my mother moved with my sister and me into a two-bedroom apartment. I remember distinctly that after we moved, Leica (pronounced *Lisa*: my mother was still drugged from her labour when the nurse asked her how to spell it) and I went back to the house to visit Dad. She and I sat on the couch, Dad in his Lay-Z-Boy, and in the awkwardness of that moment, all of us sitting stiffly in our seats, I felt the formality of this unnatural visit—a *visit*; families who live together don't visit.

In that moment, I realized I had nothing to say to my father. None of us had any idea what to talk about. My own father, suddenly, so clearly, was unknown. I was eleven at the time.

About half a year after moving out of one house, my parents reconciled and we all moved into another, one with a very middle-class in-ground pool, in the east end of Cornwall where I began high school at St Lawrence. Dana and I both went there for the French immersion program.

My troubled home life continued as Dana and I became better friends. When he and I were in grade ten, my parents kicked my sister out of the house because of a dispute over her boyfriend at the time (who later became her husband, Rolland), then a month later my parents split up for the last time, and my mother and I moved into another two-bedroom apartment.

Within a year of that move, my mother had a new partner, with whom we promptly moved in. I was generally a wreck at this time. I'd come out to myself and entertained fresh ideas of suicide. I couldn't eat supper without having to lie down partway through the meal because I felt sick to my stomach. I'd breathe and relax for five minutes and then return to the table to continue eating.

These were hard days—the usual, confusing, fag teenager kind. I was a wonderful mix of desperate, confused, enraged, and terrified. One random afternoon in my emotional soup, my mother and I had a fight over something inconsequential. All my resentments about growing up in a tumultuous home boiled over. We had a rip-roaring argument in which I screamed so loudly I lost control of my mouth—I felt drool

pour down my chin, and I spat as I yelled. I could barely stand up, my body shook so violently. After we'd both said the cruellest things we could think of—I hope that's as cruel as we could get—I charged into my room. My mother followed a minute later, threw garbage bags at me, and told me to pack. She called my father to come get me.

Dad was living with Leica and Rolland then. They had a spare room, and Dad had needed a bed after a split with a girlfriend. This was during his own period of suicide attempts, which Leica mostly kept secret from me.

I slept on Leica's couch for two weeks until I wrote my mother a letter to explain that I was struggling with suicidal thoughts. It was as close to a coming-out letter as you can imagine, though she didn't catch on to that part. She finally phoned and invited me back home to live with her and my stepfather. It was the last fight we ever had. We cleared the air, I guess, so the years since have been good ones. Having said my piece, I could forgive her.

Not longer after this mess, the safety and playfulness and camaraderie I felt with Dana, the thrill of him, translated into romance. We were seventeen. It was a bumpy start for us because he fell in love with me at precisely the same time he began dating one of our best friends, Michelle. She was the date; I was the secret. Dana had the heartbreaking idea that he could love me but date her because we were two different genders, so what he did with me didn't affect his relationship with her. If I had been a girl, he admitted, he'd have to tell her, but something about the gender divide, and being queer in the

late 1980s in a small town, made him think we were fine if kept a secret.

I didn't mind the secret part as much because it was safe-making, but I was much too monogamous to share the great love of my life. I wasn't about to break up with him either—I was accustomed to difficult emotional attachments. So after a few months of torturous negotiations, when my friends wondered aloud why the hell I was so reactive to Dana's relationship with Michelle, whom I also loved dearly, I gave Dana an ultimatum.

Dana chose me. We were together for four years in total, from the ages of seventeen to just before I turned twenty-one. I went from being a virgin at the start of our relationship to having the kind of mind-blowing sex you only get when you're young and starting out, when your sexual synapses are firing for the first time, waking up each tiny point of contact your skin has with the world, whatever it touches—bed, finger, air. We had sex for six hours at a time, three orgasms each, crawling slow and slippery as snails over each other's skin, five or more days a week. Sex, I came to believe, was a place of safety. It was a place where I wasn't alone.

Those years of emotional paddleball were accompanied by puberty, when the sense of difference I felt from the other boys went from being a big secret buried in my thoughts to hard evidence, literally. Erections hit at the worst times when boys were around: playing in the grass, being tackled, in the locker room, the bathroom, standing in front of the class. The shame of being attracted to men and the panic that I might be

found out made desire a trap. I felt betrayed by my body, which quickly translated into a fear of it.

Worse still, in my mid-teens, acne hit. I suffered with acute acne on my back for ten years because I refused to go to the doctor. (When I did finally get medical help, the acne specialist said, "Oh my god," when he saw my back. The official term on my chart was the charming Latin phrase *acne vulgaris*.) If I accidentally hit an inflammation, I was in severe pain, nearly to the point of passing out. But I told no one. It was a simple, debilitating fear. Nobody saw me shirtless, let alone naked, for a decade. Even Dana was banned from seeing my back for the four years we dated, including the two we lived together. Sex happened in the dark or in the daylight only if I wore a shirt. We never discussed it.

I weighed a whopping 125 pounds between the ages of sixteen and twenty, and I was six-foot-one. I was a young, fey, gay guy, a poor excuse for a man by the measures of masculinity in my small town. I was so thoroughly ashamed of my body, so fearful of it and afraid to be seen in it, that any new place made me anxious. I rarely used public washrooms; I could spend a ten-hour day out of the house without peeing. I was uncomfortable with my own sweat, so I avoided almost any activity that would make me perspire. At the worst times, I even felt panicked in line-ups, because people could see me. I was trapped, with no practical way to be invisible.

Dana was a saint, I can see in hindsight. He had so much patience with me.

Our four years together were a blessing, because he made it clear that he loved me unconditionally. We didn't break up for a lack of love but a lack of compatibility. Realizing we did sex way better than marriage, we began translating our romance into friendship, which means we broke up but had sex together for another six months.

Part of the complication was that the season we broke up, I lived in Cornwall for a summer job but travelled back to Toronto to visit my friends there. Dana had been my best friend through high school, so where else would I stay when I was in Toronto but with him? I promised myself I'd get out of the emotional amusement park as soon as I moved back to the city for school and had a new place. I needed to get on with my romantic life. (I had a decade of mostly unsatisfying short-term relationships to look forward to.)

On my last trip to Toronto to apartment hunt in the summer of 1992, I crashed with the ex for a week. I'd found a place to live, so on my final night in his apartment we both knew this was it, the end of the end. We quickly landed in bed together and fucked languorously. I travelled every inch of his body, memorializing. Every fleshy piece held our history—his armpits, slim arms, and meatier legs, a small patch of chest hair, and the smooth skin behind his ear, his dick that we'd agreed was the same length and girth as mine, his hairline, smooth broad shoulders, and the dusting of hair in the crack of his butt all were made museum pieces, scrapbook pages, mnemonic devices of our four years together.

After an hour of rolling around, Dana asked if I wanted to try something new.

"New?" I asked. I think my head must have cocked to the side. What hadn't we done before? He reached into the side-table drawer and pulled out a black three-tiered dildo, each bump more intimidating than the last. The final night that my first boyfriend and I slept together was our first night with toys.

"I bought this," he said with a crooked smile.

Without missing a beat, I thought, *I knew you were missing me.*

"Okay, I can try it on you," I said, trying to sound enthusiastic.

He smiled shyly. "I've already used it. I want you to try it."

I looked at the stout silicone pole, gulped, hesitated, gulped again, and agreed. He wrapped the black dildo in latex and then lifted my legs to rest my feet on his shoulders.

He began working on me. He rolled it in circles, wiggled it back and forth, pushed, grunted, and teased me with it until, what must have been twenty minutes later, I felt my hole stretch as if I were about to birth a baby elephant and silicone bumped against my ass cheeks.

"I'm at the base?" I asked, sighing with relief.

"That was the first hump," he answered with a smirk.

I invented a new form of incredulity, to match the moment. Half an hour later, we finally had the whole thing inside me. I felt like he'd impaled me on an obelisk. A monument to our relationship. Endorphins did somersaults through my blood. My heart felt like its valves were trying to stretch in competition with my sphincter. It was incredible. My body was incredible. Our love, even on the cusp of this heartrending breakup, was incredible.

When he pulled it out, I'd never felt so alone.

"Want more?" he asked.

I could only nod my head.

He lowered his hand toward my butt, without the obelisk, and slipped a few fingers inside me, then a few more, until I felt a peculiar collapse. The pressure on my hole vanished as though his hand had shrunk. I shot him another surprised look.

"I have the whole thing in there," he said, which was a phrase far simpler than its implications.

I looked down to see his arm pointing toward my perineum; his hand disappeared inside me. I was a hand puppet. When he started to wiggle his fingers, I thought, *That settles it.*

Half an hour later, we traded places. When I was buried to my wrist inside the man I'd never have sex with again, I was pure amazement.

Let's take a pause with my hand inside him for a moment to try to explain for those unfamiliar with fisting the particular mystery of this sensation.

A nurse I used to drink with once described to me his first day on the job in cardiac care, when he saw a man's chest opened and a doctor manually pump the man's heart in his palm. My hand felt just as otherworldly, like I'd slipped it right inside a ventricle, enveloped in the living warmth of Dana's body. Here was a new means of studying human behaviour, with touch. It was the same magic of communion that Helen Keller must have felt the first time she recognized a word on her hand.

To recognize an object through touch is called haptic perception. (Not that I recognized what I was touching; I was haptically illiterate.) The concept of extended physiological proprioception, according to the all-knowing Wikipedia, is that "when using a tool such as a stick, perceptual experience is transparently transferred to the end of the tool." Wrap your mind around the notion that with a hand inside another person, both parties experience proprioception—he is the tool that extends from my hand, and I am the tool extending from his ass.

Fisting altered my sense of inside and outside, of the body's border, or the borders of selves. To date, fisting is my best experience of the embodiment of the profane and the sacred. Our vulnerability in that moment was complete, encompassing, thorough. Love is never more acute than when your interior is in the hands of another.

That anal handshake has remained the most intimate of my sexual experiences. The blurring of the borders of my self—the fusion, the mirroring—was juxtaposed with a keen awareness of that other person, that sentience I trusted with my own.

Now I remove my hand from Dana's ass to widen the conversation a little, if you'll indulge me a moment more.

Many years later, after that most intimate wave, we've seen the rise of Internet porn. A trove of fisting images are now easily at your digital fingertips. The web has brought fisting home. I'd bet my foreskin that a large majority of young gay men raised after the invention of the Internet see sexual acts online before

they engage in them. You learn by watching videos how to fist before you meet the man who first puts his hand inside you.

Most electronic fists wear leather cuffs and torn denim. The receptor's ass hangs over the edge of a black sling strung up with chains. The handsome man, buried to the wrist, calls his horizontal partner "bitch," "faggot," "whore," "slave," etc. Fisting, as demonstrated in porn, is predominantly a product of domination. It's not like I expect to see much of the real world in porn—or all their dicks would be five or six inches—but the contrast between my fisting experience with that of the porn world is incongruous. And illuminating.

Why aren't these moments of intimacy intimate? Why are these extraordinary circumstances reduced to physical exteriors, to exertions? Why does the emotional moment in porn get reduced to control, with the bottoms as receptacles of aggression? (As viewers, we aren't invited to involve our hearts or heads, just our bodies.) Is the baseness of the act hardwired? Why can't men be vulnerable in porn without being dominated or dominating? Why is it all about the beast, the animal, and not the personality? Why is our choice of beast never a lamb? Why don't the fisters use their free hand to smooth the hair of the bottom, tucking strays behind his partner's ear, holding the side of his head in his unlubricated palm?

My best friend, Colin, has complained that once, during a hookup, a Vancouver, BC, man spoke to him with a Brooklyn accent, saying things like "Suck dat big dick." The dude took on the accent only once they started fooling around. "Canadians don't talk like that," Colin wanted to say. "You're talking

in a porn accent." Sex talk has become a poor byproduct of US-dominated porn tropes. It's as ubiquitous as small-town white boys parroting inner-city black rappers.

And maybe it's petty, but isn't it worth asking, as a purely aesthetic critique, why all slings are black? What's wrong with lavender, teal, baby blue? Think about pink, which could add such a nice glow to pasty skin. Don't say, "Black masks the colour of shit," because porn is full of pale sheets and nobody thinks anything of it.

If Susan Sontag, in *On Photography*, is correct in saying that, "in teaching us a new visual code, photographs alter and enlarge our notions of what is worth looking at and what we have a right to observe. They are a grammar and, even more importantly, an ethics of seeing," then what do fisting videos tell our young gay men about intimacy? What is excluded in their right to observe? What are the vocabularies of gay male sex evidenced in our representations of it?

I'm not asking us to censor SM porn, which is hot, or condemning the use of domination as a tool for getting off, which is also hot. I'm asking for balance. I'm inviting us to be the men who insert our hands in another with the awe inherent in that moment. I'm asking for the love fist. I'm asking for the rubbered hand of tenderness.

A good portion of the magic that made Dana family—still family, always family—is his complete disinterest all those years in what a man is or isn't. Dana wanted to be Dana, which offered such a comfort to me, who for so many years didn't want to be himself.

In the year after we broke up, Dana began wearing dresses, first at home, then out in the world. She began a transition from fag to lesbian. More or less. She was always bisexual, but after she transitioned to woman she had monogamous relationships exclusively with women. You'd think that knowing her for ten years, during four of which we were lovers, I'd have had some sense, but I didn't. We were both feminists; we saw how misogyny and homophobia were both gender-based prejudices. We called ourselves queer when few people wanted to be. The only small hint I could have had about her gender was that when we went to shopping malls, Dana couldn't tell whether a clothing store had men's or women's clothes. She always wanted to go into Suzy Shier, thinking they had men's jeans. Ironically, Dana began to wear women's clothes the same time I did, except she was trans and I was, hmm … exploring.

Living in Toronto during my early twenties, I carried around a thoroughly debilitating shame for my body that was the exact size and shape of it. Much of that shame was both homophobic and gendered. Regardless of where you learn it, pretty much everyone is taught at a young age to fear being gay. (Despite the It Gets Better Project and anti-bullying strategies, which didn't exist when I was growing up, gayness remains *the* schoolyard taunt.) For those of us who are queer and those of us who think we might be gay, which includes those of us who have had gay thoughts, those of us who stumbled alert from a same-sex reverie, those of us who enjoyed a touch by a person of the same sex, been intrigued by someone gender variant and maybe stared a little too long, or even taken pleasure in the

presence of a person with the same gender signifiers, it was not "the other" on the playground who we were taught to fear but ourselves.

Fear of one's self. That's got to mess anyone up. In our years together, Dana and I patted ourselves on the back for doing a damn good job of overcoming the social stigma of being same-sex cocksuckers and fudge-packers. Like other queers in the western world, we'd done a solid job of coming out and demanding to be counted as equal, regardless of what we did behind closed doors.

In those early years of being out, I grew more and more aware that our homo fear wasn't as tied to a sexual stigma as it was to a question of gender. In our great sexually liberated movement, we may have been proud to say whom we had sex with, but repeatedly I witnessed how the other men among us were loathe to risk losing cultural influence by being "faggy." To be "femmey" was a great weakness. They could love a butch, even if she was a woman, unless she wanted some of their cultural power, and then they weren't so sure. They scratched their heads with annoyance and disbelief at those of us on the spectrum of trans. Straight-looking/straight-acting became a mantra for gay men in the early 1990s (and the sentiment, if not the language, is thriving more than two decades later). Queer women embraced the butch and the femme and the spectrum in between in a way gay men haven't dared. The women amongst us aren't risking a loss of the gender-power they never had.

One evening in August 1992, the power of femininity revealed itself to me when, as a lark to celebrate my best friend Paul's birthday, he and I decided to do drag and go out to the bars. Everyone had always said I'd make a beautiful girl, so it was time to find out.

I put on a curly blonde wig and an orange A-line dress ... and the clouds parted, and the sun shone down, and I was gorgeous.

Everyone said so.

I felt it, through to my bones.

I realized the first time I put on a dress that my chicken legs, too often mocked, now looked enviably thin. My slim waist, long arms and neck, my love of colour, my humour, my ability to mix and match, my love of sewing and hair-styling, of bobbles and shoes and shoulder bags, all suddenly fit well into one terrific soft-lensed portrait of femininity. I was committed to drag in that instant because it allowed me a means to celebrate my 125 pounds. In a dress, all the gender terms were suddenly reversed, and I fit. Drag gave me a means to celebrate the limp wrist, for it was no longer limp but feminine. That faggy women's lib empowerment—wherein others judged me as a gender success—disappeared the moment the dress was unzipped.

The next day, though, I could tell that a little piece of me liked a little bit more of me.

Eight or nine years into her gender switch, Dana said that she couldn't wait for me to transition too because I was already becoming my own kind of genderqueer. By the end

of my twenties, I was painting nail polish on my thumbs to
go with the skirts I wore to work at my part-time job at the
UBC Bookstore. Given the option, most things I bought were
pink. I pierced my ears. I hung out with mostly queer women.
And I owned more pairs of heels than your average pageant
contestant.

I thought about Dana's observation for a long time.

For our years together, through high school and into my
early twenties, clothes had been my security blanket, my dis-
guise. When I was twenty-seven, a therapist once asked me to
describe the steps I took to dress that day, and I talked for ten
minutes about the outfits I'd tried on, what I'd hoped they'd
do, and how I'd hoped they'd function, until finally settling on
what she saw before her.

Clothes had been a tool for disappearing. If I was expecting
to be out for the day, I couldn't leave the house until I was
satisfied that what I was wearing was appropriate for work,
the poetry reading, and the dance club that night. It was debil-
itating. Some mornings it took me an hour to figure out what
to wear. If I came home before going out again, I could spend
another hour once more choosing the right clothes.

It wasn't so much that I was obsessed with the clothing,
because I hated the small range of colours in men's clothes
(brown and black and grey and blue, sometimes green) and I
hated most men's wallets and shoes and belts (in brown and
black and grey and blue, maybe tan). I was obsessed with fit-
ting in. Clothes were my only route to confidence, even though
I resented most of the options in menswear. If I wasn't going

to act the part, I thought I could avoid scrutiny by dressing the part.

The kind of masculine behaviour I'd been offered in my small town came with tying cats' tails together and hanging them over a clothesline, snapping the necks of birds, or breaking pretty much anything that could break just to watch it break. Masculinity, in my experience, had been destructive and mostly solitary. Violence could be done in packs, but it was an act of solitude as a rejection of what is; it divided you from the world. I had had enough of that in my family life.

I think that Dana, having come out as trans, recognized that I was undoing my gender colour by colour. Trying to reconcile my paradigm of manhood with my love of the feminine was confusing. Loving all things girly, I felt like I was trans, but I was also happy being male, just not being a man. I didn't like what manhood offered me.

To reconcile these oppositions, a short time after Dana spoke with me, I told people I was transitioning. I was a Male-to-Male trans guy. MTM. I imagined that second male was a man of my own devising.

Although I abandoned the term publicly, I've carried it around as a reminder. MTM has been productive for remaking what I think a man is, what I want a man to be. As a continuation of the fresh perspective I had when I finally admitted to the world that I was gay, so I could throw off the burden of what a straight guy was expected to be, thinking of myself as MTM was a further relief, as I could abandon what it meant to be a man.

Pretending to be straight had been so bloody boring, but pretending to be a garden-variety man was even more limiting. In coming out I wasn't just seeking the freedom to do in the bedroom what I wanted and with whom; I was after the celebration of my whole self, the whole complex person I had hidden away in there. After MTM, it was clear that the biggest bonus in being gay was abandoning the prescribed rules and rituals of being "a man." If I felt like it, I could wear pink. I could be tender in public. I could cry at movies. Paint my nails. Read Paglia. I could jump for joy on the street corner. Kiss men hello. Use colourful adjectives. Be polite. Admit my fears in public. Be kind and sensitive.

Because I live that "gender edit" on the street as the proverbial man in pink pants, folks shout "Fag!" out their truck windows at me. They are creating a separate category for what I am, a subset of man. They recognize that my gender is a performance, a failed performance. I don't fit their narrative of that gender. The threat I pose, whether they are conscious of it or not, is that by performing a different myth, I reveal that their gender is a myth too. Their gender is also theatre.

One of the biggest bolts of insight to strike my flagpole didn't occur to me until grad school: fags can still be men. So simple and obvious, but that insight had eluded me in my early life because I had created another category of man to accommodate fagdom. The two categories felt mutually exclusive to me. The thought that they overlapped stopped me in my tracks in a stairwell. I lost my balance perched above the remaining steps. It was like I was looking at one landscape from two

perspectives, trying to establish that they weren't different scenes. I was a man. I was a fag. Fags could be men. Men could be fags.

From that day forward, the queeniest guy in the world was still a guy (if he wanted to be) and therefore my definition of a man had to be broad enough to encompass him. When I considered all the different types of men out there, it became a lot harder to say what a man was. Two decades later, the category of fag has proven to be just as kaleidoscopic. Trans men, butch women, and genderqueers of all types and textures might identify as fags. If we're paying attention, we can see how the shorthands we've used to label genders and sexualities are about as articulate as playing charades with your hands tied together, in the dark.

BLACKOUT! AND OTHER DISAPPEARING ACTS

But I'm suggesting that we define humiliation as *the intrusion of an unwanted substance or action upon an undefended body.*
—Wayne Koestenbaum, *Humiliation*

I DON'T KNOW HOW I first heard this story, whether my father told it himself, or if this was a hand-me-down from my sister. The images are visual enough in my head that I suspect this came directly from Dad. Because so much of my father's life was a construction, I've learned to imagine the pieces, and what's in between the pieces, as part of a search for the truth of a story. I learned to listen as much to what was left out—the improbabilities, the illogic, the poor judgments—to determine how much was true, how much was booze-fuelled, how much was hiding his mood in the moment, how much was a search for pity or money or, what I thought might be a truth realized too late, how much was a search for comfort.

Dad was drinking at his usual bar Chez Louise, shooting the shit with a guy all afternoon, until they got onto the topic of

Dad's teeth. His top denture had broken months before (he never explained how), and without a job he couldn't afford to get it replaced. He didn't have coverage, and welfare didn't provide dentures. For about two years, he had to change his diet to eat only foods he could gum because he couldn't really chew. (The first thing he ate when he eventually got new teeth was corn on the cob. "Ah," he later said, throwing back his head and staring at the heavens, "it was amazing.") Without dentures, he ate a lot of pasta.

This guy at the bar hears Dad's woeful tale of the food he's been missing out on and the occasional cuts and scrapes he gets on the roof of his mouth from trying to eat something crunchy, and he says, "Maybe I can help."

It turns out he's an undertaker. At this point, I imagine the guy as much taller than in my first sense of him. His fingers are long and pale, with impeccable nails. He's clean-shaven.

The undertaker invites Dad back to his workplace. Obviously, they're both drunk. They take a cab halfway across town.

Once at the funeral home, they clunk down the stairs into the basement, to the rooms nobody else gets to see, where the bodies are prepped in cold storage. It's like a large filing cabinet with oversized drawers and industrial handles. The undertaker walks into a storage cupboard of shelving and emerges with a bucket full of teeth.

Used dentures.

Dad is welcome to any pair he likes.

I asked my father if he'd found a pair, and he scoffed out a "no" that had its own question in it: He wasn't wearing new

teeth, was he? Dad had a way of telling a story that left you wanting more of it. It was the only question I had at the ready.

"What was wrong with them?" I asked next.

"They just"—he twisted his hand in the air, exasperated and annoyed, as though cupping imaginary dentures that wouldn't screw in properly—"didn't fit. They were uncomfortable as hell."

At first, when your father tells you a story like this, it's amusing and shocking—you're thinking you can't wait to get home to tell someone. Then a landslide of questions presents itself, all the things you can't possibly ask but are dying to know: Just how drunk were they? Maybe the undertaker wasn't drunk? How drunk would you have to be to pull a set of dentures from a bucket in an undertaker's basement and slide them into your own mouth? What did that taste like? Did they pile them up on a table as they went through the bucket? How many did he try on? Did he go through the whole bucket? How were they sorted? Were there elastic bands around each set? Were they in sandwich baggies? Had the teeth been sterilized? How long had it been since they'd been washed? Why weren't they buried with the corpses? (The answer to this last one I happened upon later in an article—dentures don't burn in cremation.)

I can remember Dad sitting at the wooden table in the kitchen, eating a slim, fried pork chop, teasing out the story carefully, more out of awe than bragging that he could have been the person in the story. Did he really do this? Is that possible? He was testing out the truth of his memory by making a sounding board for it.

Dad was full of mysteries, uncomfortable ones, mostly. There was the time when I was in high school and he was living alone, when I opened his medicine cabinet. I don't know what I was looking for—drugs maybe, something incriminating. I wanted to know more about him; I wanted a clear sense of his depravity. I found a blue cylindrical plastic case, about the length of my palm. I was sure it was drugs. The tube was in two sections. I separated them, and the smell of shit hit me at the same time that the colour brown did. This was a travel toothbrush with feces smeared all over it.

I put the cap back on immediately and placed it in the cabinet as I'd found it. With my hand on the cabinet door, I debated if that was the wisest thing to do. Did he know it was there? Would he find it later? Shouldn't I just throw it out? But what if this wasn't a drunken thing, what if it was something else? Even today I can't imagine what that something else would be. Clearly he'd been drunk and done something ridiculous or maybe an ex-girlfriend had.

Despite the grossness of his denture story, something in Dad's telling of it was heroic. He'd been so reduced by poverty, he'd tried on the teeth of the dead. Telling this to me was both intimate and manipulative; here was a confession of his vulnerability and an appeal for financial help. Both states (I knew to frame accurately) came about because he was a drunk.

My own versions of poor judgment due to alcohol began after my final split with Dana, when I lived with my best friend Paul in Toronto. We did nearly everything together, including drag.

For New Year's Eve in 1993, we dressed up for a Dungeon Party at Buddies in Bad Times Theatre. In that era, their infamous events were way more dance bar than dungeon. Still, wearing a bright slip dress and feather boa at a mostly-leather party, I was an exotic bird in a field of cattle.

Just before midnight, servers walked the periphery of the room carrying trays of small plastic glasses of champagne. I took one in either hand every time a server passed and quickly got soused. When the countdown ended, emboldened by my fabulousness—I was in Canada's largest city, attending my first party in drag, feeling liberated by anonymity—I walked against the flow of teaming shirtless bodies, kissing every man I passed. I must have smooched a few hundred in twenty minutes and still my lips didn't hurt. Such was the resilience of youth.

Halfway round the room, I bumped into the cross-eyed guy who'd tried to pick me up when I'd first arrived. He'd seemed way too aggressive when I was sober, but now, light as a feather, I thought, *Why let first impressions interfere?* A drunk's logic is far from scrupulous or sound. I reasoned that maybe he just found me so hot he couldn't help but try again. What's more flattering than determination? It was panty-freezing cold outside and we were horny so we headed for the nearest warm place to fool around: the bathroom.

We waited in line for ten minutes for either of the two stalls in the men's room, though only one stall was emptying. Impatient, I peaked over the wall to see two dykes snorting lines off the porcelain. I wasn't one to complain. Eventually this man and I were also hogging a stall, making pigs of ourselves.

We swapped blowjobs and fucked and generally pissed off a lot of pissers.

My buddy Paul was in line for the coat check, about to go home without me. He later said that every time the bathroom door opened, he could see my wig above the stall wall, bobbing like a pom-pom at each thrust. It was an hysterical, all-time low. (I now know we live to outdo ourselves.)

Somebody spied over the top of our stall too, to see what was taking us so long, which only seemed fair. I heard him tell the crowded room that we were fucking. Well, I was like Zorro, wasn't I? Mysteriously in disguise.

When I stepped out of the stall, with my head held high and my wig askew, I heard a gasp. I didn't recognize my schoolmate Doug in his heavy Goth gear until he shouted my boy name over and over again. Doug had a voice like a five a.m. garbage truck—foul, grating, and disruptive.

"Michael Smith! I can't believe it's Michael Smith!" he chanted.

Thankfully, there's a certain anonymity that comes with a boy name like mine.

Now and then, during the five years I lived in Toronto, I wondered if I was hot enough to have a man pay for sex with me. I was as naïve as I was insecure: I thought selling sex would prove that I was attractive and worthwhile. The thought of it made my dick throb against my jeans. As I rode the streetcar past Elizabeth Street where the hustlers hung out—their shoulders drawn back, chins up whenever a car turned the corner—I'd imagine what it was like to be them.

After a night of drinking and dancing, my buddy Loralee convinced me to try it out. "Go," she said, giving me a little push. "Make us some money. Then you can tell me all about it." She had said "us" as a joke; she didn't expect to share my profits, but I asked her why she didn't trick if she was so interested in the sexual transaction. She replied that it wasn't as safe for women on the street as it was for men.

Four blocks away, as I drunkenly stood on the corner at two o'clock in the morning with only one other guy half a block down, a car rolled slowly past me. I was terrified and wasn't sure Loralee's argument was sound. My legs shook like a pair of rock and roll drumsticks. All I knew about tricking was from television. I had no idea if I needed a pimp or if someone owned this corner. I imagined scenarios with people threatening to knock me around and the things I'd have to say or do to appease them.

After about an hour of standing around, sweating, shaking, and biting my lip, a portly white-haired man came sauntering up the street. As he walked by, I nodded hello. He nodded back. Ten minutes later, he came around the same corner again. This time, he stopped to chat.

He was friendly, which I thought might be a trick to get me somewhere dangerously private. He weighed about a hundred pounds more than me, which, if things went south, would be to my disadvantage. Then again, I reasoned, everyone weighed more than me. He asked how much for a blowjob. I had the wherewithal to ask if he was a cop. He chuckled and said no.

Getting picked up in a car sounded a lot hotter than walking

the two blocks to this guy's apartment, but there weren't many cars. The kid across the street was still standing there, pacing in the cold. I felt lucky.

In his untidy condo cluttered with piled magazines and VCR tapes but nearly devoid of furniture, the guy paid me up front. Fifty bucks (and this was in 1993).

We undressed. He was an abominable snowman, covered head to toe in white fur. He lay back. I blew him on the bed for nearly an hour. Either he deliberately refused to cum so he'd get his money's worth or he was almost as turned off as I was. Finally, just as I thought my jaw would unhinge and hobble home without me, he began to gasp and I beat him off until he came all over his chest.

Hungover the next morning, I could barely move as I reached for the ringing phone. Loralee had called way too early for how late my night had been to ask how it was.

"Boring," I said, and hung up.

In 1995 I moved to Vancouver for grad school. Without Dana or Paul, no one made the decision for me to go home when I was out for a night on the town. So I didn't. I'd had only a few blackouts and a couple of unwise sexual scenarios in Toronto; I didn't realize until I was living on my own that my drinker didn't have an "off" switch.

Dad was again suicidal at this time. Every few months, either he or my sister Leica would phone to tell me the latest terrible event. He was in an alcoholic soap opera, like if *Coronation Street* had Canadians instead of Brits. I was hyper-aware of how

much I drank, but because I didn't go out that often, I thought I was fine. Drunks drank every night. Drunks anticipated the next time they could get drunk. Drunks rolled cars and got kicked out of their girlfriends' homes. I didn't own a car, and I didn't have a partner, so I just needed to better monitor my intake.

I began leaving the bars, where I wasn't getting any action, and cruising the parks. Park sex had an old-school glamour about it. There were the stars. The smell of the pine trees. Being partially naked outside.

An older homo friend took me to a public park the first time, so that it felt frightening but also safe. He gave me pointers, which I picked up fast. At the time, I thought myself so square that it was a thrill to do something that seemed illicit.

Over the years, alcohol and I had made a few nasty misjudgments. In Toronto I'd gone with a skinhead to a tiny little parkette in the Mount Pleasant district. He drove us way up there from the Church Street village. We made out beside some trees next to a creek. He pulled his dick out of a hole in the crotch of his pants. The next week, a man was found strangled next to the creek in that park. Years later in Vancouver, I met a guy in a cruising spot. We went back to his place, where we snorted lines of a powder he called "crystal." The next morning I told a friend and he yelled into the telephone, "You did crystal meth?!" and I replied, "I did crystal *meth*?!"

For the most part, my "accidents" happened a year or so apart, enough time to give me the impression that I was fine. Everyone had funny drunk stories. I was competitive so mine just happened to be better.

On the first night of my last three-day binge, I was at a big artsy house party organized by a film student at the university. She must have had parental money because her home was nothing less than a mansion in Vancouver's bougie Kitsilano neighbourhood. The host's bedroom featured a Jacuzzi tub in the centre of the room under the skylight. There was an open bar. I brought a girl friend who spent the evening mixing me Tom Collinses, neglecting to mention they were doubles.

Since the invitations had called for everyone to dress up in their best, the crowd of strangers looked fantastic. I had to borrow a jacket and pants from a friend's boyfriend because I had no fancy clothes, meaning I looked like I fit in, but didn't feel it. I drank quickly.

Most of the evening at the party is a blur. There was a cabaret show on the stairs. I vaguely remember necking with a Little Sister's bookstore employee. I left the party around midnight to take a walk for fresh air.

Once outside, I decided to jump on a bus. There was a popular cruising spot called the Fruit Loop just across the Burrard Street Bridge. I had bus tickets. Men were waiting for me. I looked fancy and hot.

When the bus dropped me downtown, I walked westward toward the Loop by English Bay. On some unknown residential block, a voice called to me from above. I looked up the height of a fifteen-storey high-rise. Eight or so stories up, a guy with his head out the window asked if I wanted to visit his apartment. From my perspective on the ground, he looked blurry and sexy so I said sure.

In retrospect, I can only assume he'd been waiting for a drunk homo to pass by. Why else would you call out to some young guy staggering down the street, and why else would you invite him up to your apartment when you'd only seen him from that distance, in the dark, after midnight?

I walked to his front door and pulled. He said something to me as I yanked on the handle, which wouldn't give. He called out a number.

"What?" I asked, looking up, but I was in the sheltered door-way so couldn't see him.

He called out a number again. "My buzzer. Enter my buzzer number. I'm in the same apartment. Don't forget it."

After I'd pressed the buttons, the console beeped at the same time as I heard a telephone ring above me.

He said, "Hi," and buzzed me in. The guy who answered the door wasn't my kind of hot—he looked like Jack Klugman playing Oscar in *The Odd Couple*—but I joined him inside anyhow.

The apartment was a tidy 1950s layout with a large open living room, a wall separating the kitchen on our right-hand side, and at the far end a dining area. The decor looked like he was cat-sitting at his mother's: the furniture was two or three decades out of date. A wooden spoon rack on the wall was filled with collectibles.

As I flipped off my shoes, he said, "So you want to make out?"

"Sure," I said.

"Let's sit here on the couch."

"Not the bedroom?" I asked.

"No, let's just make out here."

"I don't want to do it on the couch," I replied.

"We can't go in there," he said, gesturing to a closed door to our left.

"Why not?" I asked, looking around. The light in the apartment was dim. One shaded bulb was lit on the far side of the room.

"Because I don't want to," he replied curtly, trying to squash the debate.

"But I like making out on a bed." If I was going to fool around with a guy I wasn't that attracted to, at least I could do it comfortably.

"The couch is fine. Lie back, I'll just slide on top of you."

I looked to the door again, then to him. "What's in there?"

"Either you want to make out," he said, "or you want to go home."

We made out.

I wasn't horizontal for long before I passed out.

This was the first time I'd had alcohol-induced amnesia during sex. Previously all my lost memories had occurred while partying with friends (which carried a kind of cute factor), or I'd black out between my sexual escapades, usually while on my way to a public park.

My host woke me by shaking me gently. "You have to get dressed," he said tersely. "Time to leave, buddy."

My undershirt and dress shirt were off, though I'd no recollection of having removed them. After I put them back on, I asked, "Where's my blazer?"

"You don't have one."

"I borrowed it from my friend. It's dark blue."

"You weren't wearing a blazer. There's no blazer."

I walked into the bathroom to search, even though I hadn't used the bathroom. Maybe he was hiding it.

I likely came to a little less drunk than when I'd arrived, because I had the brilliant idea to check if my asshole hurt to determine if he'd raped me while I was sleeping, but he followed me into the washroom.

"You weren't wearing a coat," he nagged. "You're drunk. You left your coat somewhere else."

Reluctantly I left the apartment; he shut the door behind me and clicked the lock. I heard a chain slide in its socket as I pressed the elevator call button.

On the street, I again became convinced that my coat was inside. I couldn't remember his buzzer number, of course. I looked up at the high-rise; all the lights were off and the windows were shut tight. I tried the front door. Locked. I looked up and down the street, hoping someone might come this way and, by coincidence, open the front door.

Then I walked around the back of the building to see if there was a back entrance. No doors at the back were unlocked, but the walls of the building were stone, making ridges with grips. I looked up. He was on the eighth floor—that I remembered. I figured I could climb the back of the building. I managed to hoist myself about three feet off the ground, then decided I'd be too scared by the time I reached the eighth floor so I gave up. (I later realized I'd be crawling into the wrong apartment anyhow; his apartment was on the front side.)

Refreshed, and feeling like I was acting very responsibly because I'd had the smarts to not attempt that B & E, I wandered a couple blocks to a sex spot I knew by the base of the Burrard Street Bridge. I was still buzzing.

I blew two men at the same time until sunrise. Sunrise was always about the time I sobered up enough to be tired.

Heading home on foot, I noticed my shirts were pulled on in reverse order, so that my white undershirt was stretched over my green dress shirt. It had been like that since I'd left the dude's place.

I woke up the next morning, brittle with hangover, fearful of STIs, shame-faced, my ass seemingly untouched, and vowed never to do that again. The jacket, I found out after a few phone calls, was behind a chair at the party house.

My second-last night of alcohol, I promised myself I'd have only one drink. The evening was reasonably uneventful, except for the drunken young guy with bulgy eyes I let masturbate me at the beach later that night. He pulled my foreskin back so far he made a small tear across my frenulum. (That's the little band-like ligament running down from the glans, similar to the one under your tongue.) It hurt, I was turned off, and I walked home.

The last night of my binge week, there were two parties. At the first—a grad show for Emily Carr University—I told the friends I was with why I wasn't drinking, describing to their great amusement my excesses that week. They encouraged me

to have only one beer, then didn't say a word when I went for the second.

The next party was in upscale Shaughnessy at a buddy's house. He was married to a doctor. They provided free drinks at a pour-your-own bar, which I did, frequently. By the time I staggered out of there with the friend I'd brought (whom I'd hoped to convince to date me), I'd made a pass at nearly every man who came within ten feet of me.

We walked home. I remember the sky being gorgeous, the tree leaves lit with moon and stars. Vancouver summer nights are pure magic—the air is fresh from the Georgia Strait, giving a perfect coolness after a hot day.

When we'd walked a good half hour, we came to a cross-roads, where Todd was headed further down the street toward downtown and I was to turn right, toward home.

"I'll go with you," I said. "We can take the bus. I just need to pee."

Todd said he'd wait for me.

I walked around the corner to an alley behind the stores. There was a cluster of pine trees beside an apartment complex on a small patch of land between it and the asphalt. I stood under a pine tree, pulled out my dick to pee, then blacked out.

When I came to, I had my left hand down the back of my pants. I'd shit myself. Then I'd checked to make sure it was true that I'd shit myself.

I was surprisingly resourceful.

I picked up the dried pine needles at my feet and wiped my hand to clean off the worst of it. Using only my right hand, I

took off my shoes and pants, but not my socks; I didn't want to get my feet dirty. Then, using only my right hand, I carefully stripped off my underwear, managing to balance while pulling each foot out of the gaunch. If you've ever wondered how it is that used underwear appears in a public place—or maybe a shoe or pants—now you know, they're from drunks.

I balled the underwear up and tossed it underneath a bush.

I cleaned my ass the best I could by wiping it with dried pine needles. By my drunken standards, I found it much more efficient than I'd expected. Satisfied that I had cleaned myself sufficiently, I dressed, walked around the corner—forgetting that my buddy Todd had been waiting for me—and jumped on a bus headed downtown.

I eventually meandered into a park. I remember only pieces from the rest of that night. I had all kinds of sex, unprotected, despite the tear on my foreskin. The details are spotty, bits surfacing here and there: my dick stuffed into one place, someone watching me, a gesture, a grimace, a cock being rubbed against my ass. A good amount of the time I must have spent in the park is a blank.

About dawn, I sobered up enough to walk toward home. A white-haired guy dressed in black walked toward the curb not far from me. Earlier in the night, I'd turned him down when he'd approached me. He'd kept his distance, but had watched me now and then in the last half hour.

He said hello when we were nearly side-by-side. "Nice evening."

"It is," I said.

"You had some fun."

"I did," I answered. "You too?"

"I did, thanks," he said. Then very politely, he asked, "How are you getting home?"

I told him I was walking and he asked where to. "Cambie and Seventeenth."

"That's more or less on my way. I can drive you." He pulled out keys and clicked the remote, unlocking the doors to a black Jaguar. He wore two enormous rings, one on either hand, with dark stones in them. His Jag was likely the nicest car I'd ever been in.

He chit-chatted sweetly as he drove me home. I'm sure I must have stunk of shit and pine. Each time we were stopped at a red light, I waited for him to turn and proposition me. The closer we got, the more humiliated I was, assuming I could guess why he didn't.

The morning after, I woke to my alarm at eight a.m., barely able to move. It was May 10, 1998, my friend Emily's birthday. My blood felt like it had turned crystalline overnight—every little movement seemed to cut me—but I struggled through a birthday brunch on four hours of sleep.

I gave up drinking that day, at age twenty-seven. The exact date has been easy to remember thanks to Emily. I quit without a program, because in my early twenties I'd done a few Al-Anon meetings with my sister. They'd given me some insight and language, but I didn't appreciate the steps, and I didn't like what felt to me to be the program's victim-mentality. It smacked of a trap.

I quit by using two simple strategies. I told everyone that I was quitting. If I met someone new, I let her or him know I was a non-drinker, so there was no fooling anyone if I tried to order one. And I decided that since it was a slippery slope after the first drink, that was the one I wouldn't have. No first drinks.

That strategy has proved immensely effective to keep me sober. I've not touched a drop since, which, for the most part, has been easy. There is a persistent voice in my head that occasionally whispers options even sixteen years later—*you can order a drink in the back bar where nobody will see you; it's only wine so it doesn't matter; you've been sober so long maybe you're fine now*—but the dark times were so full of threat, I don't dare tempt fate. Watching my father and my mother struggle to keep their heads above his alcohol consumption when I was young was as effective an antidote as anything. Once I recognized that I didn't have an off switch, there was no way in hell I was about to turn the drinking back on.

The downside to not following a program or seeking other professional help is that I didn't know at the time that addictions may come and go, but the compulsion is resilient. Stripping my life of drinking didn't eliminate compulsion, it just mutated into a bigger and better foe.

BLUSH

CRUISING FOR SEX WAS an easy replacement for drinking. It was thrilling inasmuch as I never knew who might be waiting with a big stick, either a dick or a baseball bat. If I couldn't pick up men in the bars—likely, in hindsight, because I was a charming mix of aggressive, drunk, and sissy—the men in the parks were happy to have sex with me. Someone who'd dismiss my hello in a pub would see me an hour later in the park and silently do me.

In those early years of sobriety, cruising kept me out late with much more success than drinking had; I wasn't hung over, it didn't cost me a cent, and I remembered everything that happened. Enlivened by my success and the thrill of cruising's secret coded underbelly, I began having sex in the parks two or four times a week. I could have as many as three orgasms with, on average, five different men a night.

Around this time, I read the excellent *Times Square Red, Times Square Blue* in which Samuel Delany, the queer academic sci-fi writer, described his decades of public sex in New York porn houses. He explained how those intercourses were a tool in building community with strangers, where you care for

people whom you don't know, and where you are intimate with people you know little or nothing about. I recognized his argument immediately from my own experiences with anonymous sex. For a lonely twenty-something who rarely got touched, cruising was romantic. Delany's proof was in the details. I recognized in his candid report of his sex practices (in the fast-disappearing cultural landscape of Times Square) something of that necessity to do yourself justice by being open and honest about who you are and how you live your life. His book rang like a carillon through my body.

So between 2002 and 2004, I wrote a confessional sex column under the guise of my drag persona, Miss Cookie. That column, "Blush," appeared monthly in *Xtra! West*. It was a "Do as I say, not as I've done" column, meaning I aired all the sex-related events in my life that still made me uncomfortable. Each month, I sat down to discuss a sexual moment that embarrassed me. I worked my muscle of abreaction, despite not knowing the word at the time.

In the same years, I turned some of my adventures with public sex into a porn zine called *Cruising*. I made three issues, "The Park," "Bathrooms," and "Peep Shows." The zine was an insider's look at public sex, with a how-to section, questionnaires, cartoons, an "endpage" for readers to send in pics of their butts, and poems and stories, both true and imaginary, of sexual encounters in public spaces. There were graphic photo essays of Miss Cookie engaged in three-ways under the stars, furtively pulling on dick under a washroom stall, and swapping blowjobs with a boy in a cramped peep-show booth. A

favourite snapshot is my full-body in trashy drag standing at a washroom's trough-like urinal with my short-shorts undone, squeezing my erection.

My column and zine were, in my own modest way, attempts to put tell-all strategies into practice. My sex writing began as an experiment in purging shame by celebrating the sexual ditches I fell into.

My early days of public sex were lessons in intimacy. Once, late at night in the park, I remembered that I had an appointment in the morning, so thought I should go home and get some sleep. Only just then, a guy—no shirt, jean shorts, a few inches shorter than me but yummy with muscle—popped up beside me, right out of the blue, and slid his dick into a man's ass. It happened so fast.

I straightened my ball cap, telling my tired and dreamy self I should leave, but I couldn't. This little guy was slapping skin on skin. There was the noise his thighs and pelvis made slamming against the guy's ass, there was the white streak of his torso ramming back and forth, and his thick solid arm grabbing the guy by the shoulder to get a good thrusting grip on him. He was a flesh machine, all levered rhythm and force. He fucked the way I wanted a man to want me: with a single-minded need.

My arms were crossed, my head was cocked to one side, and my mouth hung open; I was agog. I couldn't believe he was real and I was watching him. I couldn't believe my good luck. *Well, what the* hell *are you waiting for?* I said to myself.

I slid my dick under his perineum. His skin was soft and hot

and slick with sweat. His shorts rubbed against me as well, so I got action on all sides.

There were men crowded around blowing each other, some fucking, some watching us. I leaned in and chewed on his neck. He was hard, salty muscle—my favourite flavour. I didn't last long. I couldn't handle the power of his ass running over top of me, the feel of my arms around his warm back, and his small nipples erect against my fingers. I came on the dirt beside his feet.

It was so nice, I got a little dizzy; the blood had rushed out of my skull. I smelled the pine trees, the dirt, and my sweat all mixed up together. The cooler night air felt refreshing on my skin after a day of hot sun and my sweaty build-up from fucking. *There's my orgasm*, I thought, *and now I should go home.* But when I turned back to that boy still pounding, I couldn't leave without seeing him cum. I stood back and watched the show, wishing the clocks would slow down. And then he looked at me like he'd heard me thinking, like he'd heard my heart whispering to him, and he looked at me square in the face, with his eyes two dark glassy stones in the night, and leaned toward me. He wanted to kiss.

I opened my mouth and tasted him warm and sweet on my tongue. There was an aftertaste of fruity gum. His tongue was small and pointed and his lips uncommonly soft. Everything he gave me was wet against my mouth.

I rolled his tongue over and under my own and brushed our lips together. I pulled back and lingered over him, my body held in an open breath above his, waiting for us to touch again.

We were millimetres apart, stretching the time like a dull melancholy ache in my guts. I wanted to kiss him again, but I needed him to want me. I needed to feel he was hungry for me like I was dying for more of him. He was still ramming like a piston in the stranger's ass, and I was giving his lips the softest touch I could muster.

And then we kissed again, lightly, his tongue reaching out for mine. I was weak inside a mess of anxiousness, slowing things down and yet dying to get to the end because the feeling was so delicious. This boy was like nothing I'd ever let myself have before. I'd never seen anything as good as he was, right then in the dim dark of the tree-covered woods. I chewed on his neck, licked up to his ear, and whispered, "I can't wait to see you cum."

He didn't smile. Stone-faced, he said, "I want to cum with you."

I blinked. He was serious. Almost instinctually—I wasn't really thinking—I answered, "Okay."

He stopped everything. He stopped fucking. The guy getting his ass reamed stood up without saying anything. He'd heard us but didn't complain as he pulled his pants up. My man said, "Let's go somewhere."

I told him he could fuck me if he had condoms and he said he had lots. He took me by the hand. We walked further into the woods to a clearing under a tall tree. I told him my name, and he called me Mikey. His name was Nick. He wanted me on my back while we fucked so he could see me.

I took my shirt off and laid it down inside out, then removed

one shoe so I could slide my jean shorts off one leg. I didn't bother to take off the rest because I didn't need to.

He climbed on top of me, saying, "I'll go slow, Mikey. Just let me know. I'm going to be gentle. Just relax." I loved the sound of his voice. There was an edge of old school there, mannered, blue-collar, full of respect.

He pulled a rubber out of his pocket and a plastic bottle, which he opened and squirted into his palm. His hand was toasty warm as he rubbed lube in the crack of my ass.

He fucked with abandon. He fucked like he was determined to drive himself mad in my ass. For the next twenty minutes or more, I couldn't hold it in; I moaned and swore and grunted and shook and bit the air with the effort of not falling to pieces as he fucked me. My back was rubbed raw against the earth.

Men heard us and flocked around like puppies at a bowl of kibble. Someone stepped on my forehead.

I told Nick through gritted teeth, "Believe it or not, I'm trying to be quiet."

He told me, "Go right ahead, Mikey, do what you have to do."

Finally, my back was killing me and I had to stop. We sat up. He invited me back to his place. The men cleared off. We got dressed. He unlocked the car doors and opened my side for me.

At his place, we curled up on a mattress on the floor in front of an aquarium that ran nearly the whole length of the wall. He put his arms around me as we watched the fish darting inside the tank. Then we fucked again.

At one point, I had such a pool of sensation welling up, I

thought I might explode into tears. I had to get the feeling out of me. It was like an orgasm of the senses, but it wasn't cum flying out of me but feelings—living, pure *living* about to burst out of my skin. I didn't know if I could handle it much longer, but then the feeling passed and I didn't lose it and we stopped fucking and he came so far with a hand job that it hit his face.

Then he fell asleep.

We fucked an hour and a half later because it was morning already.

I had to go to a meeting at ten a.m. He took forever to get ready, so I had a shower at his place and we drove to the other side of town where he dropped me off. We didn't kiss good-bye because rough trade was standing on the street corner just outside of the car. I had his phone number.

At the door to the office where I had my meeting, I knocked. No answer. I was wearing my clothes from the night before: a shirt filthy on the inside, jean shorts, no underwear, and runners now covered in dirt. I knocked again and still there was no answer. Ann, the counselor I saw to discuss my father's drunken suicide attempts, was late.

My ass twitched, telling me I had to fart. Something didn't feel right. I farted into my shorts, blowing bubbles out of my ass. With too much lube from the three fuckings, I blew too many bubbles into the jean shorts and wished I had worn underwear to catch the bursts as they clung to my hairy hole. *Please*, I thought, *don't let me drip through my pants.*

Ann arrived. I cleaned myself in the bathroom, and she was none the wiser. For the course of the hour-long meeting, I had

to squeeze my ass cheeks together to hold in more farts as we discussed again the various reasons why I couldn't get a boyfriend.

Bit by bit, sex with strangers became a means to try stuff out, to invent a self. If the school playground hadn't offered me a means to discover my personality when I was young, anonymous sex gave me a venue to experiment with new selves without risk of exposure.

One winter when it was too cold to cruise outside, I remembered that I'd received a free pass for the phone lines. I posted an ad to fit within its culture: I lowered my voice, spoke in short sentences, and used simple adjectives. After some back and forth messaging, I found a man with his own deep voice who was willing to travel. I had described myself as tall and slim, looking for a fun, friendly guy. I neglected to mention my exact weight.

When Brian knocked on my door, I opened it with a warm smile only to see his expression drop and the words "skinny bitch" flash across his face. He literally glanced at my body and slumped ever so slightly. I'd seen that look a million times: men scanned my coat-rack figure wondering where all the muscle was. Sometimes, when cruising in the park, guys would start to make out with me, grab my arms, squeeze, then drop them and move on. It enraged me every time, but what could I do? I could have called these men out, but half my rage was because I thought they were right. I *was* too thin.

Brian was broad-shouldered, about five-foot-ten, with

sharp blue eyes, unkempt straight hair, and easily two days of stubble. He had that outdoorsman-in-the-big-city look (as it turned out, he was a school teacher who shopped at Mark's Work Wearhouse). His plaid shirt, hiking boots, and blue jeans made him butch, but without a trace of personal style. He was vanilla-hunky.

Uncertain if I really wanted to risk further insult, I invited him inside, just to see. Gingerly, he came in and sat down. We chatted about work and the leather-and-denim bar and the 'burbs where he lived. He was reluctant to reveal much, which either meant that he was shy and adorable or disinterested and soon to disappoint me. He wasn't exactly fun, but he was friendly. Despite assuming he wasn't going to sleep with me, I liked him. He had a way of speaking that was gentle, perhaps insecure, while still being a dude, and that combo felt rare. Plus he was a little cross-eyed. Always a win.

When I couldn't stand my undies getting any itchier for him, I asked if he wanted to neck. He answered, "Sure," with a shrug.

Okay, I'm not the hunk he expected, I thought, *so thank god he's hornier than he is discriminating.* I jumped on top of him before he could change his mind. I made out with him aggressively, partly to compensate for what I thought he didn't see in me.

Half an hour later, after teasing, pinching, and slapping him around, he flipped us over so that I was pinned to the bed underneath him. Both of us naked. In that brief pause while we rested, he whispered in my ear, "Do you wanna role-play?"

"Sure," I said, although I had never played pretend in bed

before. Not role-playing pretend, just I'm-with-Jeff-Stryker imaginings. I asked, "What do you wanna do?"

"Daddy/son," he answered.

As a joke, I asked, "Which am I?" His dick was in my ass crack. He weighed thirty pounds more than I did. It was obvious.

"Daddy," he answered. "That okay?"

"I can do that, Son," I said, faking a confidence I didn't have. I had no idea what I was doing. I was thoroughly aware of his weight and my weightlessness the whole time, but I played my way through it with equal parts wits and imagination. Those I had.

We spent a good hour inventing a family history, mostly with me as the aggressor and him as the penetrator. I was the aggressive Daddy bottom. He was the passive Boy top. That mix was another surprising switch for a guy who dressed lumberjack.

I was shameless in describing to him what we were doing, inventing a history and a context for the moment. He loved it. At one point he paused, resting on his elbow to ask, "How often do you role-play?"

When I told him I never had, he said he couldn't believe it. It was a win over his first impression, but in that moment, with this grown man with two days of stubble and a chubby dick looking up to me, I felt myself to be unfamiliar. I had a kind of power, a sexual dominance, which I hadn't known even with Knievel. This man-boy had invited me into a very graphic exercise, demonstrating how my own sense of self had created

a set of limitations that I hadn't seen were there. I could be a successful father figure, despite being younger, smaller, and terrifically unsure.

Brian then asked if Daddy wanted to screw him for a change.

By morning, I'd worn out more than the cliché about what you got and how you use it.

By 2001, I'd had great success with the "Park" issue of my zine, selling 250 copies, some in stores, some by mail. The subculture of public sex was fascinating to me: its rules and rituals, the wide swathe of men who used the park, the range of raunch and tenderness that you could watch or engage in. The writer in me was a people-watcher—I liked to see how men tick, and I liked to see them vulnerable. Cruising was a great way to do both. The bonus was that I got lucky too. Every sexual encounter at the time it was happening was a comfort. It validated me. I felt seen, even when in disguise.

That year I decided to do another issue of the zine, more out of curiosity, I think, than as a reason to get laid. The second installment of *Cruising*, I decided, would be an issue on bathrooms. I didn't know much about washroom sex so I asked for a tour from C, a friend who knew which places downtown were popular for lunchtime action. I'd never cruised a bathroom before—everything I knew came from word-of-mouth or porn.

C gave me a few key pointers, such as the foot-tapping under the stall to indicate you were interested, and seeking out washrooms with two entrance doors, especially if the first one was

squeaky (so you'd have a second's warning to straighten up before a new person entered the next door). After ten minutes at the urinal in a food court he'd taken me to, my buddy managed to land a real date-date with a handsome silver fox, a pastry chef popular in washrooms across downtown.

When C told him what I was up to, the pastry chef came out to meet me because he had some thoughts for me too. He told me that if you wanted oral, you could do it at the urinals but anal could only happen in the stalls. You could squat with your legs on the toilet, so that folks only saw one pair of shoes.

"But I knew a guy who used paper bags to give head," he said, laughing.

I didn't understand. "What for?"

"To stand in, to hide your legs," C said, nodding his head and smiling.

The pastry chef added, "So it looks like one guy is sitting on the toilet, with his shopping bags on either side of the stall."

C chuckled. "That's thinking ahead."

A week later, I cruised a public washroom for the first time solo, for research. I was nervous. I'd chosen a mall known to have man-on-man action, especially with businessmen at lunchtime. Despite the informational tour from C, I wasn't sure what I was shopping for. I wasn't interested in being arrested, and being arrested seemed a very distinct possibility.

I stepped cautiously through the washroom door. There were three different varieties of man hugging the urinal wall. I thought immediately, *I'll blend in*. I took an open spot, pulled out my dick, and waited. In short order, all three guys began

pulling on themselves. Another man stood at the sink washing his hands very, very thoroughly, and eyeing us. Behind me, an enormous man lumbered out from an open stall door. He looked discouraged, like he was waiting for a late appointment. Everyone was gay, it seemed, at least for the time being. No one spoke.

For nearly half an hour, men came and went. Men masturbated. A few pumped someone else's dick. Some guys actually came to pee. The rest of us pressed tighter to the porcelain and pretended to be pee shy until they were gone. Then the skin pistons started their slow rhythms again.

Nobody kissed, nobody bodysurfed a tongue over skin. It was disappointing. I wasn't buying any of it. I was a fag with all kinds of sexual interests, from the perverse to the banal, but mute, mutual masturbation was too button-down-collar to interest me. Worse still, I couldn't stand the interruptions. In the middle of the anti-climactic action, I kept wondering, *For god's sake, can't someone lock that door?* Each time the first of the two sets of doors squeaked open, everyone involved jumped to attention, hiding their perky pricks in the basins. I kept banging the head against cold porcelain, collecting germs, I was sure.

We had to wait until each new arrival either peed and left, or he'd assessed who was lingering too long, gave a leer, and jerked himself as well. Too often, kids came in. I'm sure the inappropriateness of place and the fear of being caught are part of the appeal for some men, but I felt the bad kind of dirty. My swollen dick penetrating a piss-filled basin with sweet kids

hanging around made me feel depraved. Being queer was an upward effort to leave shame behind, not wallow in it.

I'd had enough public humiliation. When I was sure it was just fags and their lovers left, I grabbed the hand of a cute suit and dragged him into a stall. After I put my feet on either side of the toilet seat, he kissed me sweetly. But even a stall proved to be merely semi-private. The man in the john next to us wedged his face between the floor and the base of the stall wall, peering up at us. Always thoughtful, the suit tried not to step on him.

I introduced my guy to every dick's favourite new friend: my tonsils. I blew him until he blew.

As I readied myself to leave, the suit tut-tutted and shook his head. He pointed to me, then to the spot where he was standing, then to himself and the toilet seat. We switched places.

He went down on me, tenderly, which I loved. My hands were in the back of his salt-n-pepper hair, trying not to mess it up on his lunch hour. I felt the warmth of his neck in my palms. I must have spent just as long kissing him as he did servicing me. We filled the rest of his lunch hour.

Alas, it had to end, and with a kiss it did. We straightened our respective tie and ball cap and walked casually out of the stall. There were some new faces mixed in with the previous pud-pullers. For a moment, I felt taller, like I was the best-dressed fag in the room. I'd found some very mutual intimacy with a frisky businessman, though by the time I'd washed my hands, he was gone.

About this same time, I started to think that being a public sex

slut might have been taking up a lot of the time and energy that I could have invested in a more steady relationship. If I was always whining that I wanted to be in a relationship, why was I spending all my time looking for casual sex?

I started to try out new skills that were closer to dating than cruising, such as meeting men outside of the parks. That helped me to discover a truism I'd never intuited: If you're out in the world having fun and a guy asks you where you're going next, most likely he wants to be invited. Before knowing this, if I'd wanted to hang out with someone, I invited myself along. And if I wanted to fool around, I was known to say something witty like, "I live ten minutes away. You wanna take a ten-minute walk?"

Drag queens don't make their mark being subtle.

So to improve my ability to find a boyfriend, I'd stopped being direct with men. Instead, I spoke in code. One night at a house party, Owen asked me what I was doing next. I said I wasn't sure, but did he want to go to the Dufferin Hotel where my friends were headed? (I was a fast learner.) Later, at the Duff, I asked if he wanted to walk home with me.

When Owen and I left together, it made my knees tremble. Sure, he had a weak chin and, though twenty-seven, had been out for only two years, but his slow smile was killer. He had a lot of the qualities I liked best: he was artsy, smart, and easy to entertain. We talked about my sissy wardrobe (I must have been in pink) and his twenty-five years in the closet.

Once at my place, I invited him up for a toke. We talked into the wee dark part of the night until finally I admitted I wanted to

kiss him. When he took five minutes negotiating aloud whether that would be the right thing for the two of us, I should have been alerted to the subtext—he was tentative—but he ended with a "yes," and that's all I heard. We had some very playful sex.

I'm not usually a biter, but he was so into my nibbling that I decided to go there. The more I chewed on his rawhide, the more he groaned in a good way, and the more my molars hunkered down. The next morning, I realized our mistake when Owen went to the washroom and didn't return.

I found him leaning over the sink with his head in his hands, nauseous. He'd had a small bit of blood in his urine. There was no pain, he said, so I told him not to worry, he'd burst a blood vessel. I'd learned from the sex exploits of friends (who engage in "sounding") that blood in your pee could happen when you're a little too rough.

He came back to bed. I fantasized our wedding. Then I had to pee too. While washing my hands in the bathroom sink, I checked my face in the mirror and found large streaks of dried blood smeared across my cheeks. I washed up, crawled back into bed, and gently told him what had happened.

We did the HIV talk, and then I curled into him, purring, "Don't you worry, I promise that if we ever do that again, I won't slap your bloody dick across my cheeks."

"You can't say a word of this to anyone," he said.

Without thinking, I answered, "What do you mean? I've already hung your bloody boxers out the window like a flag."

Owen left that morning without a goodbye kiss. He never called. My code reading needed quite a bit of fine-tuning.

For years, I would vow to cut back on public sex, anonymous sex, quickie sex, sex without a bed, but as weeks passed between touching anyone, my resolution weakened. I felt like everyone had acquired some kind of gay man's code that I wasn't privy to because I couldn't convince men to date me. Public sex gave me access to both physical comfort and distraction from lonely evenings.

Most fags I knew had met their partners in the clubs. Even on a bad night for me, the park had more action than clubs. In all my years out, I'd never picked up more than a piffle of men there—less than a handful. There was Dale, whom I took home two weeks in a row from the same Toronto bar, but only after we were both drunk; James, the businessman and father of two who was on a working holiday from hetero-normativity; Domenic, the forty-year-old whose only bedroom furniture was a mattress and television on the floor (and a television, I guess, isn't furniture); and a blond guy I met in San Francisco's Detour who kissed me up against its metal chain décor until we took the fun to my hotel room.

I used to think it was my clothes and the body in them that made men reluctant to go home with me, rather than my attitude toward them. If I was indoors, I wanted to wear something cute or pretty. By contrast, in the park where butch is *de rigueur*, I enjoyed masking myself in a ball cap, jeans, and a baggy jacket to add bulk to my torso. In the dark, I was manly.

One night in the park, I walked slowly, hands in pockets, hips not swinging, carrying my pelvis like a divining rod. I wandered off the path into the bush and found a guy leaning

against a tree. He had longish hair, either hippie or trailer park, I couldn't quite tell. I stepped closer to him. He smiled. He was wearing suburb-style denim. We didn't speak. I still felt butch.

He slid a palm under my shirt. His hands were as soft as lips, his lips like marshmallows. When I bit them, he grabbed my groin. We made out for a long time, masturbating. We nibbled and pawed each other, dropping our pants, lifting our shirts, giving just that much less than what we wanted—a perfect panty-wetting technique. I grabbed his ass. It was smooth, round, very firm, and moving in ever-widening circles. It was the best ass I'd ever held in my hot little hands.

He turned around, and I fucked him bare. Bareback, because I didn't have condoms, because he was way hot, because opportunities to do men this macho didn't come around for me every day, which in turn made me feel masculine, because we hadn't yet said a word to each other, and because I felt, as usual, that keeping silent was easier.

We fucked until we finished. I considered asking if he was positive. The words I could find all sounded rude, so I said nothing. I pulled up my pants and left.

Walking home, I did what I always did after having risky sex: I unravelled with worry. In the 1980s, I came out with Queer Nation, chanting, "Silence equals death." My friends worked for Vancouver's YouthCo. One wrote a column about being HIV-positive and others organized the AIDS vigil each year. How could I do this? I was negative, or had been negative. I may still have been negative. And I knew better.

The next morning when I woke up, my face burned with

shame. My gut was electric with panic. I wanted to cry, curl up, and hide. If it had been some other problem, I likely would have called my mother for comfort, but this was too queer for her. I phoned my best friend, Colin, who was only a few years younger than my father. One of my best unconscious strategies for thriving had been to find older people who would invest in me, such as my grade-ten high school English teacher, my best friend's mother, and Colin.

He said he knew that horrible feeling. He'd done similar risky-sex things before. We decided to try never to make that mistake again.

"Worrying isn't going to help," he said, "so get tested in six months, but stay safe till then."

I talked to a number of friends about that night, and then again later when I experienced others like it, to will the silence away. I didn't realize it at the time, but this strategy had similarities with quitting drinking: I was trying to create a community of witnesses so that everyone would know I had put myself in danger, and I hoped that it might dissuade me from doing so again. That pattern was also cyclical, running in tighter and tighter repetitive circles.

In my first *Cruising* column, I'd announced a promise I hoped Delany and other sexperts might be proud of: " … to lay bare the ins and outs of our sex culture as I experience it. We're going to talk about everything we don't want people to know. We're going to wring the neck of shame, roast it, and make a meal. We're going to get comfortable." The experience of describing

on paper a dirty little secret was exactly as Wikipedia describes abreaction. Confession held a kind of sweet dissipation. The fingers of shame released their grip.

Beyond that particular kind of sexual release was the true gift. As the months passed, it became more and more obvious that I wasn't just confessing; I was also seeing my own complicity in the messy circumstances. Prior to writing that column, I'd catalogued much of my behaviour as He-did-this-to-me or This-funny-depressing-thing-happened. In the articles, it became increasingly clear that I-had-a-hand-in-all-this-shit. Sometimes literally.

Because I published an uber-graphic zine and a confessional sex column, projects that graphically detailed a sex culture many men engage in but few discuss, a lot of people assumed I was comfortable in my skin. One company, for example, asked me to do glossy magazine photo shoots to promote a new type of clothing for the penis. When I told them that, given my attitude to my body in the very recent past, I considered myself to be the last person they should ask, they thought I was kidding. What most people misunderstood was that I wasn't baring all because it was easy; I made nudist and graphic sex work because exposing the nitty-gritty of my body, my gender, and my sexuality scared the shit out of me.

Circulating a magazine with my erect dick in it was, in part, an attempt to demystify my sexual body. I exposed everything to purge my fear of being seen. Not surprisingly, my body became less obscene when my sexual life did also. In making my erection familiar, I punched holes in my own shame.

My zine said, *See me. I'm aroused. No big deal.* (It's an aver-age-sized deal.)

Blush and *Cruising* were first attempts to pump my sexuality into the narrative of who I am. They created a place to set down my experiences as a sexual creature, to turn them over and find some perspective. I've had a simple motto ever since: If you can't talk about it, you shouldn't be doing it. The inverse also became clear, of course, though it took many years of fucking up to see it: that just because I *can* talk about it doesn't mean it's wise to do.

Much of my writing has attempted to move the conversa-tion about our intimate lives forward, to use my experiences as a sexual man (a sometimes sexual man, a sometimes man) to hold up a light to Western world queer life in the hope we might read a bit of who we are today from the shadows cast on the bathroom wall.

People have since remarked that sharing these confessions must take a great deal of courage, which I wouldn't say is accu-rate. I've more candour than courage. To that, they make the counter-argument that it takes courage to have candour, but I don't believe that's true either. Courage doesn't call us to action. Conviction does.

GENDERFUCK

Manhood goes in many different directions, and … to say, "I am a man" is not a transparently clear utterance. Am I really a man? Is it easy to know what a man is? Do I become a man just by saying, in an act of performance, that I am?

—Wayne Koestenbaum, *Humiliation*

ONE OF MY COMMON cries to the universe on the nights when I literally sobbed myself to sleep in conservative little Cornwall, Ontario, was *Where are the people like me?* There was Dana, of course, to whom I clung, but as a group of one, she felt rare rather than like a community.

As we grew out of our teens and into our twenties in the early 1990s, we didn't find our people in Toronto either. Likely because it's hard to find your kind when you aren't living your own best self. Dana was in the closet about being trans, and I was trying to train myself not to be too terrified to be looked at. I'd hoped I might find my people in Vancouver, where I moved to in order to do a creative writing MFA. Grad school

fine arts, right? It'd be full of handsome young men eager for an artfag romance. No such luck. I met wonderful writers there who've become a solid bunch of colleagues a lot more famous than me, but no gays.

Only when I was done with the degree and most of my writing friends had moved back to whatever city they'd come from did I start to find the queers. With the simplest of invitations, life exploded.

Kim Kinakin—who'd been in the popular Vancouver alt-rock band Sparkmarker—sent out requests to join a queer punk collective to all the gay artists and weirdos and politicos he knew. Kim wanted to see more alternatives to the mainstream silos of LGBTQ events where all the types only hung out with their own types. His idea was simple and wildly productive: by using a LISTSERV (which was new enough at the time that the technology felt intimidating yet progressive), we could accumulate an audience of interested queers for alternative events in Vancouver. Folks could sign themselves onto the LISTSERV, and anyone could email when they had an event to announce. This was life before Facebook. It worked beautifully.

The first event Kim planned was a concert at the down-and-dirty Cobalt, when it was still a dive and *sans* scenester. His new band, the Skinjobs, was queer punk with go-go dancers. The band had a *Blade Runner* aesthetic; everyone sported Daryl Hannah's black eye streak. I was immediately in love with all of them. After that first buzz-happy concert, I joined them as one of their drag-queen, punk-rock go-go dancers. During the next three years, our goal for each concert, as the three bandmates

put it, was to upstage them. We blew bubbles, threw water, stripped naked, deepthroated bananas, fed suckers to audience members, and generally made ourselves a dancing spectacle.

To participate in the Queer Punk (QP) Collective, poet Billeh Nickerson and I decided we'd do what poets do—organize a literary cabaret. We wanted to meet other queer writers and artists; we wanted them to meet each other. At this same time, I began to cruise the parks, and I felt my sexuality explode with possibility and opportunity. My back acne had cleared by this time, thanks to medication so harsh they warned me I could go blind, though I thought the stats made my risk worthwhile.

Billeh and I started a performance night at the Dufferin Hotel. To inject some perv into the poetry, we called the night "Skank, A Literary Smut Cabaret." It ran about once every six months, hosting writers of smut and transgression alongside stand-up nudist comics, composers of opera, and performance artists. It was high art with lowbrow content—an embrace of the underbelly. Our guests included every gender, they were pansexual, and from all ages and creative disciplines. We wanted to create a queer space where everyone was welcome.

When Billeh and I were in the early stages of organizing and agreed we were both going to host, I said, "We can't have a queer cabaret without a drag queen."

"I don't think that's necessary," he replied.

When I pressed the point, saying queer wasn't queer without genderfuck, Billeh asked wryly, "You want me to do drag, Michael V.?"

Although I was a mouthy, assertive smart-ass, I was terrified

to let Billeh know how much I wanted to do dress-up. It was okay to put on a dress, but it wasn't okay to let folks know how much I wanted to.

"I've done drag before," I replied. "I can be the drag queen." I half-expected him to scoff, *Who do you think you are?*

"Okay," he said, "if you want to. Sure."

I'd only once done drag in Vancouver up to that point, and not very creatively. Now that I wasn't drinking, my blonde Ontario character wasn't much fun; she no longer suited me. But I'd been dying for a good reason to put on a dress again, to show Vancouver (where even the geeks worked out at the gym) that my stick arms and legs could be sexy. Most of my dress-up was in boxes at Paul's house in Toronto, so Skank was my good excuse to spend some money I didn't have in order to feel attractive again. The next day, I bought a short black wig at Dressew, Vancouver's costume emporium, and found some cheap heels and dresses at a Sally Ann. There's no better feeling in the world for a bald man who once had hippie-long hair than to put on a wig and *tease* it.

The Dufferin had three bars: a main space for dancing and drag shows, a side bar for karaoke, and a lower bar with a male strip show every half hour. Rumour had it that the boys were paid only five dollars a song—they usually did three in a row—but many of them used it as an advertisement for other services. When we pitched Skank to the Duff, we asked if we could roll their strippers into our cabaret, which they were happy to do.

My friends loved the Dufferin; it was one of the best things

about Vancouver. Friends from Seattle came up just to spend their evenings there. Everything happened under that roof. Or better still, everything could happen. The Duff held promise. I saw my fair share of drug deals, break-ups, staggering drunks, cartwheels, train wrecks, cat fights, hand jobs after the lights came up, fifty-something cross-dressers blowing off steam from their day jobs in construction, trans queens we recognized from their ads in the back pages of *Xtra! West*, and thin shirtless boys not old enough for chest hair.

The stage downstairs at the Duff was three feet off the floor, but about the width of two duffel bags or maybe twenty loaves of bread. Everything had to happen in tight quarters. I'd heard the story about the dancer who'd fucked a barbecue-roasted chicken on that stage. Another night, he walked out the side door to the lower bar partway through his song, completely naked, with a Coke bottle up his butt, and returned about a minute later before the song ended with a lit cigarette. He was fired months before our show, but that was fine, because we had Rylee.

Rylee was a young blond married man (ahem, straight) studying at Simon Fraser University, who danced, he told Billeh, because he loved getting naked. His moments on stage were more performance art than strip show. In one Skank piece, he wore an alien mask but was otherwise naked as he tried to drive a twenty-inch knife into the glass monitor of an old television set. Each full-body thrust of the knife skidded off the surface of the television screen toward Rylee's bare feet and shins. I prepared in my head what to do when either he stabbed

his leg or broke the glass and shredded his hand. Thanks to a guardian angel who admired his bar skills, the music stopped before he could do himself or the TV damage. Someone later told me that Rylee got fired from the Duff when, after an argument with management, he showed up in the lower bar wielding a match and shaking a full gas can around.

Anything could happen at the Duff.

At Skank, we filled the lower bar wall-to-wall. Hipsters mixed with feminists mixed with artists mixed with academics mixed with the post-retirement regulars who'd first tried out being gay when most of our parents were in diapers.

At the first Skank night, my high-heeled legs shook so badly when I climbed onto that small propped-up soapbox of a stage, I seriously imagined tumbling off my heels and cracking my head. *If you trip*, I told myself, *drop straight down. It's the shortest fall.* For the purposes of that night, I decided to invent a new drag persona, a sober one. I wish I had a genesis story that's full of profound insight, but Miss Cookie LaWhore exploded out of me like a character from *Invasion of the Body Snatchers*.

We booked Tralala, a performance artist who was already a Vancouver institution, to appear onstage toward the end of the night. My guess is that she was the first woman to strip on that stage. To conclude a reading about her days in the sex industry, Tralala moved the microphone aside and asked the DJ to "hit it," which meant Larry the bartender pressed play on the cheap CD player. Tralala did a small, slow dance until she was stripped down to her undies, which were stuffed—she was

packing. Tralala is mesmerizing onstage. She comes with her own spotlight because her pale skin has a faint trace of blue beneath it, a blue so soft the eye can only see it in contrast with her red hair. She appears illuminated.

Down to just undies, Tralala didn't even as smile as she squatted quickly and picked up a bottle of white glue placed at her heels. She twisted the cap, held the bottle over her head, and squeezed. Globs of white liquid dripped onto her body, like self-made *bukkake.* She rubbed her hands in ecstasy over her creamy skin, making it look, um, creamier. From inside her panties, she pulled out a small beige teddy bear. Raising it to her mouth, Tralala tore out its throat, splitting open its neck. Fake blood dripped down her face. She was a red and white sticky mess.

In heels, she bent over slowly, twisting at the side, which I came to love as one of her signature impressive moves—nobody else can swivel at the waist and touch their toes with Tralala's ease and sauciness—then picked up a small, full, white plastic bag. She held that over her head and pulled her hands apart, splitting the bag in two. A mass of white feathers dropped from between her hands onto her body. She was tar-and-feathering herself, swapping tar for a kind of seminal glue.

As Billeh introduced the next act, I went to the women's washroom, which was both our green room and backstage. The evening had already been a watershed. I'd been onstage in drag, wearing ridiculous outfits and being funny on the microphone. People looked at me as I let out all my girlishness, and it was a success. It was as if I'd been walking around my whole

life with bandages on my face and they were suddenly cut away. My skin breathed in the smoky air of the lower Dufferin bar and felt newly unencumbered.

Stripped down to my fishnets—without undies, because it's easier to change if you don't wear any—and black bra, I rifled through my bags and realized I'd miscounted my outfits. I didn't have anything new to wear for my final intro. Tralala came in to get cleaned up, still sporting feathers. Riding the high of so many homos crammed into a small room to watch other homos do dirty things onstage, including me, I plucked the largest feathers from off Tralala's body and braided them into my fishnets to cover my crotch.

I asked Tralala if I could get away with this as an outfit, and she didn't hesitate: "Totally. You *have* to wear that."

Walking out in nothing but bra, fishnets, stilettos, and feathers, I felt a chrysalis open inside me. Until then, I'd always worn clothes, whether boy or girl outfits, buttoned up to the chin. I'd always dressed to cover both the acne scars on my back and my body hair. In my early, mostly drunken days of drag, I'd also disguised my crotch and body hair because they would interfere with "passing."

Now, with the crowd at my stilettoed feet, I waved a hand around my groin, and said, "Tralala's not the only one who knows what to do with feathers."

In that moment, I was a lightning rod, struck by the power of possession. It's the same feeling in the expression on Manet's *Olympia* or in Poitier's character retorting, "They call me *Mister Tibbs*"; it is the rising up unapologetically as one's self.

I felt I'd such conviction that I was sexy, I'd seduced a whole room into believing it too. Fabulousness, I learned, came not from the clothes, but from the gall to wear them. An outfit sparkles brightest if people who see it think, *I could never wear that*. The most fabulous thing about me that night was simply that I let myself be.

Over the next four or five years, the QP Collective busily put on art openings and poetry readings and film screenings and fundraising dances. I did drag pretty much any time I had the chance. Skank ran for three years, with our final show at The Penthouse strip club. I learned how to pole dance for that event in heels, but got so nervous the night of the show that I forgot all the safeguards and bruised myself into physiotherapy. The Skinjobs toured queer festivals like HOMO A GOGO in Olympia and Bent in Seattle with bands like The Butchies, Pansy Division, Tracy + the Plastics, and The Gossip. I emceed at HOMO A GOGO, giving introductions for Eileen Myles and Kate Bornstein. Life as a genderqueer was far more validating than life as a boy next door, which I was never good at.

By my early thirties, I was donning skirts as boywear to both art shows and work. Any day was a good day to walk up Main Street dressed all in pink. I'd gone from being the guy who was neurotic and paranoid about what he wore out of doors, who tried to fit in, to being the guy who'd wear anything.

One warm Sunday morning after an event, I was having brunch with my queer women friends at Slickity Jim's Chat 'n' Chew, a Main Street hangout in the years before hipsters grew

beards. It was me and three of my besties, all amazing women: writer, teacher, and activist Amber Dawn; Trish Kelly, who'd organized all-ages punk shows throughout the Lower Mainland while still in high school, helping to create the riot grrrrl movement on the West Coast; and Zena Sharman, who co-edited *Persistence: All Ways Butch and Femme*. Women power queers.

I complained to them how my buddy Jeff and I recently noticed that we always went to events that attracted a predominantly lesbian audience. These parties, fundraisers, cabarets, plays, dance nights, films, spoken word events, and art gallery openings were totally lesbotic.

"Every time we go to something we like," I said, "all the queer women are there too. And no men."

I jokingly told them that if I were going to meet a boyfriend, I would have to hand in my lesbro card for a while.

"Jeff and I have a new strategy for meeting men," I said. "We're going to things we won't enjoy."

"That's silly," Amber Dawn replied. "You don't have to stop going to things just because gay guys don't have politics."

"I know that. I'm kidding." All six eyes turned to look at me. "Mostly kidding."

"It's not because we're queer women," Zena pronounced— everything she says sounds authoritative—"it's because we're femmes."

I placed my hands gently on the table. "Oh my god," I said quietly. "You're all femmes."

I felt my head tilt to the side to look at Amber Dawn's ruby hair, Trish's horn-rimmed glasses, cleavage, and super-straight

bangs, Zena's red-manicured nails and pearl drop earrings that contrasted with the new red leather thigh-highs she was sporting.

Their faces all said, *Du-uh.*

"I'd never realized all of you are femmes."

"Of course we are," someone piped up. Maybe they all did.

"I know butches. I like butches," I said quickly, worrying that maybe I was prejudiced. Did I have lousy politics? Had I been excluding the butches from my life?

"Why are all my best lesbian friends femmes?" I asked tentatively.

Trish patted my hand like I was a slow learner and she was performing kindness and patience. "Because you are too," she answered.

Obviously, it was obvious. I owned a pink filing cabinet, for Christ's sake. But I'd never thought of that language as being applicable to me; femme identity was a queer woman's term. I'd been busy working on reclaiming sissy and fag and feminine and girly and queer and femmey even, but hadn't thought of femme. All these queer women had been busy constructing the very solid and refined house of femme while I was shouting out other names and tromping up and down the sidewalk.

In the homo film *Gods and Monsters*, Sir Ian McKellen as movie director James Whale describes for his handsome gardener what it was like to be born a fag into a poor Irish farm family. He says, "They meant no harm. They were like a family of farmers who've been given a giraffe, and don't know what to do with the creature except harness him to the plow."

Here I'd been, unaware that I was a giraffe. It's not like I was unfamiliar with femme-identified faggots, as rare as they might have been. Writer Mattilda Bernstein Sycamore had been through Vancouver a couple times—we'd hosted her in some shows—and a Portland fag friend of mine had been kicking up femme heels as a boy long before she transitioned. So how could I be a giraffe and not notice my neck?

"How could I not have known?" I said aloud, incredulous.

"Sometimes it just happens like that," Amber Dawn answered, soberly sipping orange juice.

How weird that we can look in the mirror and not see ourselves. What is so clear to others escapes us until someone taps us on the shoulder and names it.

That moment, of course, was a long time brewing. I write about it as though it was inevitable, when really it was a mess of coincidence and unknown intention and random shit, like in a pinball machine where the ball mostly just bounces around by itself, and my job was to hit the flipper every once in a while when it was important until, luckily, it shot through a hidden channel I didn't know was there and a great bonus appeared.

Part of that femme-olution included a stand-up interactive comedy event I staged for the 2003 Fringe Festival in Vancouver. *Privates, a Public Unveiling* was simple: a volunteer handed out small sheets of paper before the show started, asking every audience member to write down their first name and the body part on themselves they least liked. The sheets were collected in a bucket moments before the show began.

I came out in drag and proceeded to remove my clothes in the first ten minutes, cracking jokes about the long tortured history I'd had with my body and its gender. Then, nude except for heels and a wig, I picked up the bucket, drew a card out, and read aloud the first name and body part the person had listed. They were then invited to show the audience their own embarrassing body part. If they didn't feel comfortable, we'd solicit someone in the room who shared that dislike for their own body to do it in their stead, in solidarity. If nobody wanted to, I'd invite the audience members to remove an article of clothing together, any piece of clothing, of their own choosing. A reviewer in the *Georgia Straight* labelled the show "an episode of *Oprah* gone horribly awry."

By the end of the show, some audience members were down to their underwear while others refused to remove so much as a shoe—which, to my mind, only proved the need for a show like that. I then pressed play on my boom box, blasted a dance song, opened the theatre doors, and invited everyone to take that body-loving courage we'd been practicing in private out into the streets. In varying stages of undress, we danced a conga line around the theatre.

About the same time I discovered Cookie, the sissy-celebrating Radical Faeries entered my life. There was a glittery pile of gender-blenders in that mix too. The faeries taught me best what it could mean to be a man and a femme.

We could spend a decade discussing what the faeries are without coming to any consensus, so here's a biased version:

each faerie is self-chosen, meaning anyone who wants to be a faerie is. Although they are pan-gender and pansexual, my group, which meets twice a year at Breitenbush Hot Springs for five-day retreats, is for men who have sex with men. That includes trans men, bi men, and anyone who self-identifies as a man and "gay," though, as with anything a little hippie, there are always paradigm-benders.

The gatherings at Breitenbush are characterized by two main organizing principles. First, every morning there is a Heart Circle, where faeries sit down to listen to anyone who wishes to share what is in his heart—I call it the Witness Program, where we all take part in listening to stories—and second, all gatherings have drop-in events/workshops that are entirely participant driven, which means you can choose anything from ball torture to croquet. Add to that mix a healthy dose of genderbending and you might have a sliver of an insight into what an average day can be like up in the woods of the Cascadia mountains with more than a hundred gay men interested in creating an alternative community.

The goal of a faerie gathering (to my mind, because you could get a different answer from everyone) is to come together to share in a community of generosity. That means a generosity of spirit and self that, depending on your tastes, can range from sex to conversation, silence to abstinence.

Another key faerie characteristic is permission. The faeries are great at celebrating a person's individuality at the same time as they seek community-minded living. If a man like my father were going to describe them politely, he'd say

something like: every freak under the sun is welcome and celebrated for being the freakiest freak they are. The counterweight to this individualism is their notion of a tribe, that we come together as a community of men who self-identify as faeries. One person's indulgence extends as far as another person's critique, and between those two perspectives arises a dialogue.

Perhaps the last main feature worth mentioning is that most faeries take new names, sort of like New Age types claiming spirit animals, but more playfully. Faeries choose names that range from nicknames to taunts, from the profane to the sacred. Some choose something silly (Pussytoes, Bubbling Banana, Strangé That's-French-You-Know); others take a moniker that embodies a way of being in the world (Princess Daddy, Gentleheart, Morgain Lessloss); there are also plants (Pansy, Acorn, Waterlily, Jicama), verbs, waterways, magical creatures, and, yes, spirit animals.

On my first trip to Breitenbush for a gathering of the Radical Faeries, I was sick to my stomach with excitement. My bones vibrated. Starting to do drag in a butch-obsessed gay community in Vancouver, I felt like the biggest sissy in the whole of Canada. Imagine you're a young Quentin Crisp living on a pig farm. Picture men in rubber boots spitting on soggy grass that you're trying to manoeuvre over while wearing suede shoes with an impractical heel. Not that Vancouver wasn't cultured, but I was struck by how everybody either worked out or was athletic. Five days with soft-hearted gay men promised to bring a wealth of blessings.

Not least of which, I'd have men to wear dresses with.

Just before five a.m. on my first morning at camp, the sky was still winter black. I lay in bed for half an hour listening to the moist breathing of the other three men in the cabin. It was still two-and-a-half hours to breakfast.

Determined to find my people fast, I snuck out of bed at six. I knew from my Vancouver faerie friends that folks did dress up at mealtimes so I put on a full face of drag for breakfast. I wore two wigs—a light blue in the front that feathered out into one with black curls at the back. My dress was skintight crushed velour. Purple. With a zipper across the chest.

When I arrived, people nearly howled with enthusiasm; turns out nobody goes to such efforts on the first morning. Makeup, morning makeup especially, was as rare as a smart quote from G.W. Bush.

My dear friend Lloyd, who goes by Darlene the Ambassador's Wife, announced at breakfast that each year he brought outfits by theme. This year, his theme was rhinestones and beads. Every outfit was geared to show off the jewellery. "I've had furs, lace and sheer, hats. It changes," he said, stirring milk into his morning coffee. His manner of speaking was gentle, almost meek, but full of a kind of authority that comes from *sagesse*. Darlene, being the (pretend) wife of a (nameless) ambassador, makes everything sound reasonable.

He tapped the spoon on the edge of his cup. "We have to keep it fresh."

All the enthusiasm I had for the weekend of outfits blew up in my face like a bad fart. Why had nobody mentioned themes to me?

At lunch that day I wore a thin dress, small enough to scrunch into a purse. For mealtimes, if you're in the small minority who dress up in something to cause a spectacle, the faeries tinkle their glasses as you parade through the dining room to show it off. It's a sissy runway with a few leather outfits thrown in.

After my meal, I approached Lloyd.

"Darlene," I announced in a loud voice, "you only told me when I got here that you do themes. You bitch," I said, and she giggled. "I won't be outdone. I've decided to do Twos."

I opened my purse and pulled out a bathing suit. The bottoms were a toddler's one-piece—meant to fit over diapers, making room for my small ass—but I'd cut off the upper straps, so it simply looked high-waisted. The material intended for a child's torso stretched over my lower abdomen, with a tiny row of black sequins lining the upper edge of fabric. It was hot pink with black polka dots. A small black vintage dickey completed the top.

In the middle of the dining hall, I stripped down and re-dressed, then did a second walk.

At each meal, I pulled out another outfit, stripped, and walked, so by lunchtime on our second day all the faeries pounded their tables and chanted "twos" just moments after I'd arrived. It was glorious validation, as a once neurotic-to-be-naked person and a lonely sissy in the world. A

roomful of men was demanding I put on something tight and femmey. A roomful of men was happy to see me naked.

The best moment in my faerie life, which convinced me without a doubt that these were my people, came on the fourth day of the gathering. I'd done dress-up for every meal, but I'd go back and change for the afternoon when I was done. That last lunchtime, I had eaten early, changed into jeans and a hoodie, then went back into the dining hall looking for a friend.

Just as I entered, the faeries began to clink their glasses for someone dressed fabulous, so I turned to see who was behind me. Nobody. Someone called my name. The room was clinking for me to walk, in boy clothes. Boy clothes, they knew, were drag. The faeries thought me tinkle-worthy in them too.

For New Year's that same year, instead of committing to get a boyfriend, a resolution that had proven a failure for nearly a decade, I resolved to take steps at self-improvement to get a boyfriend. Thanks, Therapy.

Over tea one afternoon, my buddy John and I analyzed my approach to men. We were both loudmouths who had learned to be so to compensate for being shy and socially awkward. John's greatest strength was that he was fearlessly honest; he'd say anything to anyone. I used to think it grew out of his nearbrush with death from a cancer-AIDS combo years before, but no, his partner told me, he was always obnoxious.

John isolated my two main strategies. "First, you're a ham," he said, "like Phyllis Diller."

That, I realized, was my default method, where every

MY BODY IS YOURS

conversation was a chance for me to make a goofy one-liner. Phyllis was a charmer, people liked her, but she never said anything of substance. Or if she did, the rib nudging made it hard to tell. You don't date Phyllis. You certainly don't kiss her. Eventually, you bore of her show-off antics and turn the channel.

"And then there's your Medusa," John added.

"Medusa?" I said. My eyebrow raised in threat.

"You chew 'em up. You pounce on them," he said. He cupped imaginary tits in his hand and shook them like a weapon. "You're all boom boom boom," he continued, swinging from side to side.

"Okay. How about we call her Mae West instead?" I offered.

"Sure, whatever you want to call it. That's the sexpot."

Mae was less popular than Phyllis because, though more clever, she propositioned anything that moved and a few things that didn't. She was sharp, sly, and relentless. She aggressively made men into objects. That quality was great as a drag queen—the femmes-bians loved the role reversal—but men weren't so fond of being made into objects, and especially not by a sissy.

Although the two modes of approaching men served me well in other regards—I was a knockout at parties—they didn't help me bag anyone. My pick-up rate was low. No, to get action, I told John, I resorted to my other persona, the Small-Town Boy. Friends like John had never seen him, so they doubted I could pull that one off, but in denim I could pass for butch-yet-sensitive, provided I didn't gesticulate or speak.

All three personalities, I realized, were performances. They were characters I put on to approach people, which meant, in a small but significant way, all of them were also anonymous. I was Oz behind his curtain, putting on a show.

Once I'd isolated the social characters, it was easier to recognize when I was slipping on their disguise. My mind's jaw dropped to witness how much I relied on them. They materialized unbeckoned, consistently. I saw myself turning on the jokester pretty much any time I met someone new or found a situation intimidating.

Imagine people have invited Paul Reubens for a dinner party but Pee-wee Herman shows up. Or Phoebe refuses to be Lisa Kudrow. At a public event, I could simultaneously be saying to myself, *What are you saying? Shut up, just shut up*, while making everyone laugh at a story about ill-timed blowjob vomit. I was making friends, but declaring myself unsafe.

You can have no secrets safe with me. A large part of being the socialite had meant controlling the room. My social self was, essentially, cynical. The stance presumed that nobody else was as interesting or engaging, so I'd keep everything going. That stage had room for only one showman.

Paradoxically, by studying these reflexive social masks, I saw how my girly-boy compensated extremely well for my insecurity. Rather than falter, I hid. The performance was a mask. It's no small irony that I felt more comfortable in femmey performances after my early years of being tortured by it. I'd cultivated a social power by being free and easy with my bent gender. I'd whittled it into a very sharp weapon. Trying to

embody any masculinity, however, made me feel like a female executive with workingwoman's syndrome: everyone might find out at any moment that I was faking it.

Set within that great gift John had given me was a bright gem. Social masks weren't an issue—everybody has them—but there are two kinds: those that hide and those that reveal. As much as I was embodying a slippery gender because I loved the girly parts of me, much of that was used as a femme-bully disguise.

For the rest of that year, I attempted to expose my inner self more than my ever-popular masks. Slowly, I could recognize the cues for each personality and pull back the entertainer. If a friend asked me why I was so quiet—*Is everything all right? What's going on?*—I told them the truth. I was practicing being genuine.

My best new social tool was silence. I listened to what people were telling me, both text and subtext, instead of reacting to them. I'd somehow believed that I really loved people, but I'd been treating most of them like fodder in a stand-up routine. Silence and listening made space for people to expand. They told me things. I heard them. They told me other things. I made far fewer social missteps because I was recognizing social cues. The quieter I allowed myself to be, the more I felt safe to reveal. The more I revealed, the more secure I felt. I'd created a causality loop.

When living in Vancouver in the late 1990s and early 2000s, I used to say that I was the gayest person in town. Most people

who knew me would confirm that that meant I was gayer than him and him and him and her and him and most likely him. The more I fucked with gender, the more I felt free to step out of the narrow boxes people created for me. Myself especially. I loved being a man now that I could burn up the dance floor in stilettos. Being looked at was so much easier when I was having fun. Revealing that girly-boy sense of myself was like shedding a well-used skin. I was wriggling out of the dead metaphor of manhood.

As people saw clothes making my body this or that gender, a right or wrong gender (or something in between), I recognized a familiar confusion. The binaries were giving way to a sliding scale, much like the grey scale in sexual positions.

An ancient gay riddle that has long proved unsolvable goes: If you receive a blowjob, are you the top or the bottom? You're kind of worshipping the dick if you're doing it right, so isn't that bottoming? Conventional gay thought asserts that the holder of the penetrating device must be embodying topness. But I learned from a flirty bisexual woman backstage at HOMO A GOGO that unless the bottom has pulled out her dentures *and* is being face-fucked, she's the top. She has a man's dick between her teeth. An erection can't always take the title. The power to injure must trump the hard dick at risk.

The same confusion applies to gay men in anal sex. Fags invented the phrase "aggressive bottom" to deal with this contradiction. Isn't an aggressive bottom a top if the top is more lie-back-and-relax? Who's in control if an aggressive bottom is doing all the work?

See? Confusing.

The top/bottom binaries are shitty tools for understanding nuanced dynamics, because we assume the top is the aggressor, meaning the more active participant. Top equals the power position, which is faulty logic. (This applies in hetero couplings too. If the woman is riding a man hard and he's all hands-behind-the-head, isn't she the one in control? Isn't she setting the rhythm? Isn't the cowboy the one riding the beast?) The top/bottom binary is a reductive elision of a complicated dynamic. Gender is a thousand-thousand fold more complex.

My femme identity was about to show me just how.

I donned the blue jeans of manhood—without feeling the itch of fakery—in one of the most unlikely strategies in human history, by making lesbian porn.

In 2004, I brought two queer women together into a creative trio with me. We called ourselves the Miss Nomer Collective. We made a short film of hetero-lesbo porn, called *Girl on Girl: A Documentary*. We called it anti-porn porn, because it was meant to be an antithesis to an industry employing bodies without subjectivities: our plan was to have sex on camera as two vulnerable people. I think that video is probably the best thing I've ever done.

Certainly the oddest, definitely the boldest.

In a roundabout way, our video was prompted by John Ince, owner of Vancouver's The Art of Loving sex store and founder of the Sex Party, who had created a furor in the Canadian media in 2003 by producing a theatrical event called *Public*

Sex, Art, and Democracy in which a married man and woman performed oral sex on each other. There were threats the police would lay charges. Ince drew a great deal of media attention to Canada's repressive (and old) sex laws. I'd considered attending the event, but in the end it felt like old hat—I saw folks having public sex all the time. The only surprise for me was that tickets to the spectacle were as low as twenty bucks; I'm sure everyone would have happily paid sixty-nine.

A year or so later, after the hoopla, I heard through friends that Ince was hoping to create another event to challenge sexual prudery. I had had a great deal of success producing *Cruising*. I was loving my body bit by bit, using increasingly more nude drag performances to overcome the stigma of being seen. I'd been toying with the idea of having sex with a woman for the first time, because I was curious about their bodies and my own sexual identity. I'd been in a relationship with Dana, after all, for four years without either of us knowing that she was a woman.

When I mentioned to my femme friend Tralala that I was thinking of pitching a piece for Ince, wherein I'd lose my virginity to a woman, and I hoped she would be that woman, she said, "First, I'm flattered." Then she had a bunch of questions, some for me and my motivations, and a bunch about Ince that I couldn't answer. But we both agreed we were interested.

Sometime before meeting with Ince, Tralala and I decided that if we did this, I'd do the deed in drag. You'd think I might remember when I had such a whacked-out idea, but I don't. It's a testament to how not whacked-out it was. I'd been doing so much drag that I was wildly comfortable in Cookie's skin. Drag

had always been a means to be desirable, whereas my femmey male self still read poorly in my mind. I only felt hot as a guy when I performed that minimalized self when I cruised for public sex.

At the turn of the millennium, I was also surrounded by artists doing very provocative body-based work—watching queers publicly own their sexualities at the Sex Workers' Art Show Tour and at HOMO A GOGO, both in Olympia, and at Tralala's File This! events in Vancouver, which were cabarets by/for/about sex workers and their friends. Tralala understood my decision to be in this video in drag. She found Cookie hot. And if you want to make a queer video about queer sex, being a fag in drag losing his femme virginity is interesting. We liked all the ways this film could be transgressive.

I phoned Ince and reminded him we'd met a year before when I'd interviewed him about his show for *Xtra! West*. When I said that a friend had suggested I get in touch because I'd heard Ince was looking for a possible new project, he asked me a bunch of questions that made it quite clear he didn't trust me. It took a great deal of reminding him who I was and how we'd met and what my creative practice was before he'd agree to a meeting. *Jesus*, I thought at first, *how many people phone you up every day and offer to have sex in public for your cause?*

By the end of the call, he'd apologized, explaining that since the press coverage last year, a number of loonies had called to damn him to Hell or pretended to be sex radicals so that they could get some kind of reportage scoop. He had reason to be suspicious every time the phone rang.

We scheduled a breakfast meeting for that weekend. Tralala and I began that planning session by discussing our idea of how to do a live sex show in which I would dress in drag to lose my lesbo-hetero-virginity to Tralala—a concept Ince had trouble figuring out, because how could a man lose his lesbian virginity, and why was he in drag, and what was the connection to sex, and why wasn't it straight, and why would a gay guy have sex with a woman?

We replied to all these questions, feeling increasingly like he just didn't get what queer was. I rationalized his confusion by recalling that he was of a different generation and straight, so his heart could be in the right place even if his knowledge of gender politics or transgression were dated. And very binary.

Then Ince took a sip of his tea, and asked, "So how are you going to find these performers?"

I looked at him, stunned. I think my jaw dropped. Tralala and I both paused a second. After our phone call, in which I thought I'd been clear that I was proposing to sleep with Tralala, and then this meeting in which Tralala and I talked about sleeping together, he hadn't clued in to the basic facts. Something about the drag-virginity-gender-euphoria mix confused him so much that he didn't even remember or notice that we were discussing not a theoretical set of people, but ourselves. We went over it again, slowly, to be polite—and though it seemed like a faint light bulb got a little bit brighter, it wasn't enough to illuminate the whole project.

Tralala and I looked at each other and agreed silently that we should leave it at that and regroup. We said our goodbyes

to Ince and walked across the street to my apartment to talk it out. About a week later, I gave Ince a polite phone call saying that we'd decided to not progress further, but thanked him for his interest.

After that meeting, Tralala and I were even more jazzed about doing the project, only without Ince. We debated producing the live performance ourselves, but it seemed inevitable that either we'd have a small audience, which felt disappointing for such a significant event, or we could have a large audience, most of whom would have a poor view. The alternative was obvious to both of us: we needed to make a film. My deflowering could travel the world. And each time you played the tape, that screen person would lose her virginity all over again.

We brainstormed all the filmmakers we knew who might be interested, then asked ourselves, *In front of whom would we be most comfortable having sex?*

Separately, we chose the same name.

lisa g.

lisa was a weirdo, like us. She made quirky films we both loved. She was super chill, queer, had great politics. And I thought if I could feel comfortable with anyone seeing my dick enter a woman, it would be her. We met with lisa g in person to describe the basic premise for the film. She gave us an enthusiastic "Yes."

There's a terrific irony here in that when I was a young teen, my father would often tease me that he was going to take me to a prostitute in Montreal for my sixteenth birthday "to make

me a man," and now, sixteen years later, I would lose my het-
ero-virginity to a woman (and soon win prizes for it), only we
were doing it in a way that would have made my father shit his
pants.

Tralala, lisa, and I met three times before the shoot date to
make all the necessary decisions together. We agreed that we
were working on a documentary, so there would be no re-takes,
no do-overs, and no director. We would all be self-directed.
The project would be made as a collective, from envisioning to
shooting to editing. We'd shoot the film at my place.

The day before the shoot, we moved all the furniture from
the living room into my small kitchen. We hung the bedroom
curtains over the doorway between the rooms to hide my piles
of stuff. The only thing we couldn't move was the filing cabinet
because it was too heavy. But luckily, it was pink, so it matched
my bedsheets. We placed the bed in the centre of the living
room so lisa g could walk around all sides. I put all my house-
plants in the corners of the room to create an air of civilized
warmth.

The morning of the shoot, I cleaned my body more than
I've ever cleaned it in my life. I scrubbed between my toes and
around the nails. I nearly shoved my hand up my butt trying to
clean it thoroughly. Then I applied modest daywear makeup. It
was an odd time of day to do drag. Faces in drag aren't meant
for natural light, so I stuck to a bit of eyeliner and shadow,
some cheeks, and glossy mauve lips to match my hair. Tralala
and I had agreed to wear pretty pinks and purples to match.
Even our dental dam was lavender.

Tralala and lisa g arrived at the same time. We set up the cameras. I tried not to puke with anxiety.

We began the film as talking heads, and both Tralala and I did short solo interviews. We answered simple questions about being nervous and what we'd hoped to accomplish. When there was nothing left to say, Tralala and I lay back on the bed and made out. I was a nervous faggot virgin in drag with a dyke behind a camera trained on our pubes, but it all went swimmingly.

After I tongued her thighs, Tralala gave me a tour of where they met. I chomped on her intersection until my lipstick was gone. Then I slid two fingers inside her and rolled them around long enough to realize that if I quickly separated them in a V-shape, she'd make popping sounds. I enjoyed this discovery far more than she did.

When Tralala had had enough of watching me be wide-eyed while poking her cervix, I slipped my hand out and noticed it was covered in some creamy white froth.

"What's that?" I asked her.

"It's just a little bit of me," she said. With one hand she wrapped her fingers through mine and with the other she wiped a bit of the stuff off and rubbed it against her leg. It disappeared, absorbed into her skin.

Then she rolled off the bed. Left behind on my pink gingham comforter was a small pile of the same white frothy substance. A tiny mound, about a thimble's worth. It had the look of whipping cream beaten just a little more than it should have been, but with a watery consistency. I asked

again, "What *is* that?" feeling like I'd landed in a *National Geographic* magazine.

She scooped it up with a finger and rubbed it against her leg. It seemed to disappear. I'd never seen anything like it.

"It's girl spooge," Tralala said, strapping on her dildo.

Then she asked if she could eat my ass, and I said, "No."

She asked if I was sure, and I said, "Yeah, no."

Then she gave me a questioning look and I said, "No."

After more negotiations, I decided to compromise. I let her finger me until I was ready to be fucked, which took, oh, a minute.

She ploughed my shaggy hole until we decided I should return the favour.

I distinctly remember seeing her pelvis slide down over top of my dick. It felt like magic. Truly. I briefly thought, *I'm having sex with a woman and a camera is rolling.* But the chief sensation was Tralala's tenderness. I loved her. She was patient with me, unapologetic, playful, and equally vulnerable. I'd been having so much anonymous sex with men in the dark that this experience in the daylight presented me with a myriad of challenges. And gifts.

In the middle of shooting, still wearing a wig and makeup, penetrating my dear friend and goofing around a little too, the drag felt irrelevant. I hit a point, I think, where I was freaked out and sort of woke up to the experience. I became aware of the drag, aware that it was another form of dressing up or making a mask. A separation. The drag stopped feeling sexy. My dick did too.

The instant my dick softened because the dress-up seemed unnecessary, I felt a very literal narrow door to something else inside me open and a crack of light spill in. There, on the other side of that wardrobe, was a sense of myself as a man.

That uber-femme moment led me to my masculinity. It wasn't that I was suddenly in a heteronormative coupling— we were still very queer, I was still very much into dick—but I loved Tralala with such delicious gratitude in that moment, I wanted to share myself with her authentically. I wanted her to see me.

Having wandered between the femme and butch camps, neither feels static to me. I'm still walking between them. In recent years, my sense of what a man is feels a lot less fixed. "We are process, not reality," Loren Eiseley says, which is the closest thing to true I can say about what it's been like to live in the clothes of a pink or blue system.

Being a man is created in the space between my body and its adornments (and gestures are also adornments). The relationship between my body and the clothes I put on it is live, immediate. The great literary love of my life, John Berger, says, "Reality, however one interprets it, lies beyond a screen of clichés. Every culture produces such a screen, partly to facilitate its own practices (to establish habits) and partly to consolidate its own power." Men and women are these clichéd habits. We've forgotten that men in plaid shirts and ill-fitting Wranglers reference an idea. We don't see the screen as a simple convention.

As with metaphor, when gender is a cliché, it's dead. We

forget that the flowerbed isn't a bed. The seeds of doubt aren't seeds. A boy isn't blue. We can see the live metaphor a little better if we think of clothes as uniforms: A sailor suit, for example, isn't a sailor. A naked man isn't a sailor. But a man in a sailor suit is.

A body in clothes makes reference to all the other clothes we know. A gesture is weighed against all gestures. A gender exists in the context of every other. We've created shorthand to help us know someone better, but the language has become so binary we've stopped reading the intricacies of that code. If you present a whole bunch of ones, you're a one. More zeroes? You're a zero.

I've been trying to live my gender not as a fixed thing—with its sets of pre-determined behaviours—but as a conscious, live response. I try to stay alert to how my sense of being a man changes every time someone walks into a room. Ignoring that caused me years of struggle because I wasn't a fixed idea of what I'd thought a man should be. Now I let that idea stay unmoored, so that it might ride the tide as the winds see fit.

THE OMG OF OCD

Lesson #4: It's never a bad idea to be completely honest about the facts.

—Alan Downs, *The Velvet Rage: Overcoming the Pain of Growing Up Gay in a Straight Man's World*

As I MOVED THROUGH my thirties, it became increasingly clear to me that I hunted for sex more than necessary. If I had free time, I filled it with cruising. Just as with my use of alcohol, even a small sip of porn online could get me drunk on clicking for hookups.

In 2008 I landed my dream job, teaching writing at the University of British Columbia in Kelowna, so I packed up my Vancouver life and moved to the Okanagan. A fresh start. I hadn't had sex in Kelowna; I'd never put myself at risk there. Now, I reasoned, I could re-make my romantic life. All good promises by drunks are about as ephemeral as their intentions. It didn't take more than a month for the machine to start back up again.

A typical week for me included about five or six nights of cruising online—I sometimes called it "typing class"—sometimes as few as four nights if I had other events that kept me up late. The nights when I wasn't cruising were ones I spent trying not to cruise.

Compulsion is a mild form of temporary lobotomy. Sexual compulsion is a lobotomy with orgasms. When the machinery of sexual compulsion is turned on, part of the brain shuts off. Like a blind person leaning against a touchpad light switch, you don't even know you've hit it. As the body turns on, the critical, rational brain dims.

I'd always been good at paying attention, so I caught on that in the park the encounters were brief, which didn't help my goal of finding a more long-term partner. Also I was putting myself at risk of STIs, *and* I didn't have any way to contact my sexual partners if I wanted to do the responsible thing and get in touch with them. You can only tell the clinic nurse so many times that no, you don't have contact information for the person who gave you crabs or chlamydia or gonorrhoea, and yes, you've had sex with a bunch of people since you likely caught it, and no, you don't have contact info for them either, before you figure out that maybe you need to moderate your behaviour.

I swapped out the park for online cruising sites because at least with the latter, there was some conversation beforehand and a means to contact tricks afterward, provided they hadn't deleted their profile.

Those automatic nights at the keyboard, I surfed porn for

at least an hour, usually for about three hours, masturbating. At the same time, I'd be on two other websites for hooking up, one with a chat room and one with a list of other users near me who were also online. I could have my cam on in a room and watch a half dozen other folks masturbating. I could simultaneously chat in private windows with a handful of men, jerk off on cam, cruise porn, text someone local, and browse new profiles as people logged on. In more recent years, I'd also be on two different GPS-based apps on my phone, which were like homing devices for gay guys. Altogether, they made a great immersive distraction, way better than TV. I could have eight or more different options running at once. Vibrant, interactive channel surfing. A mediated frenzy.

When really focussed, I could hit the refresh button about forty times a minute, waiting for a new profile to materialize at the top of a list when a user came online. I might spend the better part of two hours doing nothing more than that.

I could take short breaks to read a profile or watch some porn, but would quickly go back to checking for new log-ons. I got to know the other compulsive users well so that if they created a new profile I'd likely recognize them by their height-weight statistics (they often logged differing ages) and their collection of interests. Rarely was someone online any given night that I didn't already "know."

The chat on cruising sites and the too-familiar profiles found there are beyond boring. Compulsion is not sustained by novelty but by its ability to turn off our conscious mind, to distract us. The less we have to think about, the more automatic and

easy it is to disengage from the present. Having a dozen different sites going at once offers just enough distraction to be effective.

Ninety-nine percent of all my chat conversations were routine and predictable. We shared statistics of height, weight, dick length, sometimes girth (idiosyncratic, I guess, considering everything else I got up to, but girth just seemed like overkill), age, sexual interests, and, for the sophisticates, hair and eye colour. I often changed profiles, or I'd have two different sessions going using my other profile. I kept one that was more a dating lure and one for sex (which consistently had more bites).

Eventually it got late enough and I'd been masturbating long enough that I'd give up on being fussy and agree to meet some guy who didn't want to kiss or had a wife or didn't like condoms but wrote that he only wanted oral (in theory, not practice). We'd meet at my place or in a cemetery parking lot or a dog park or bird sanctuary, alongside the highway at a specific intersection, under a bridge, beside a building, in an alley, in his truck, in the parking lot of a fruit-packing plant, in the park beside his house, or on rare days, at his place, if the family/roommate/parents were out of town. One single-parent father used to invite me over while his fifteen-year-old son slept upstairs, but that just weirded me out. Anyone who tells you to be quiet when you come over should raise flags. Save yourself trouble and always decline.

On the best nights, the hottest nights, from the moment I signed off with a rendezvous until we met up, my body trembled.

It was an odd mix of deliciousness and fear, like licking the sugar off a witch's cabin in the woods. Yummy, with a pound of peril in the recipe. (My friend Colin had a similar experience when he was acting out. "My trembling was more like walking toward the guillotine and pretending it wasn't there," he told me, which is also apt. The fear made the thrill more thrilling and made it more necessary to feel like an automaton.)

My legs would shake like I'd run a marathon in heels, barely able to hold me up. My hands were late Katharine Hepburn, my arms, Jell-O. Even my stomach felt strapped into a body vibrator, shaking the cellulite. Sometimes my teeth rattled so hard my jaw began to hurt.

Much of the compulsion was in response to stress. The more stress, the deeper I wanted to slip inside the automaton. If you know anything about addiction, you will understand the perfect loop of compulsion, which is like a snake swallowing its tail—the stress of fucking up from acting out causes you to want to act out more. The more you screw up because you disappeared, the more you need to disappear again. The more sleep you lost last night, the more likely you are to lose sleep tonight too.

Compulsion has long been a means to cope with a fucked-up life. Gary the Therapist tells me that we can't get rid of our compulsive lizard-brains, but we can choose which things we get compulsive about—the lizard won't disappear, but it can be channelled into writing, for example, or playing board games or sports or doing crafts.

When I was young, I channelled it into reading. I could stick

my nose in a book for an entire morning, afternoon, and night, preoccupied with finishing the story. Nothing could penetrate that imaginary world—the parents, the chainsaw next door, the slamming doors, my sister calling my name, or the phone ringing, all disappeared. I read two or three books a week in addition to reading for schoolwork. When I was done reading my own books, I read my sister's, even though she was two grades ahead.

TV used to disappear me too. You could try talking to me when a good drama was playing, but you'd be lucky if I noticed you'd walked into the room, let alone spoke. My attention has always had the potential to be immersive. It's a great device for finishing novels. It can really help put you ahead of the pack at work. It means you rarely lose things, because you tear the house apart five or six times until you find it.

In my early years as an adult, compulsion wasn't much of a problem. I poured my attention into school and books. I lived with Dana, then with Paul. But when I stopped drinking in lonely Vancouver, I kept up cruising, in full force, because I had more time. Many days I walked home at dawn with the birds chirping madly overhead. They were comforting. Dawn is a gorgeous time of day. I rationalized how lucky I was to be able to see the sun peeking over the city and smell the air before the exhaust thickened, despite what might have transpired in the hours prior. When I got home, I went to bed, happy to be safe. When I woke up, I'd vow not to waste so much time, do so many men, put myself at ever-increasing risk. In a day or two, I'd do it all over again.

The depth to which I clued out was proportionate to the risk—if the risk wasn't high enough, I was too conscious. For a time, it was thrill enough to meet people anonymously. Sex with strangers turned my critical thinker off. When that got to be routine, it was fooling around with someone in a park. Then it was a cluster of men in a park. When parks got too routine, it became peep shows and too-public bathrooms. Peep-show rooms were great because they were a public establishment—technically only one person per booth was permitted, though nobody, not even staff, paid attention to that. The narrow aisles made it easy to watch all the drama (this too was better than TV). When the aisles and booths got boring, there were glory holes for peeking through. Then using.

It took years to get accustomed to any particular environment. The clientele changed enough from one night to the next that the lustre of the illicit remained intact until both the behaviours of a place were recognizable and my own response was predictable. I recognized that this or that behaviour would prompt a particular response in me. When I grew very adept at recognizing the patterns of a place and its clientele—because I studied the rules—my automaton stopped taking over. It got bored, I guess. In some ways, cruising was an elaborate testing lab for human nature. I'd spent my childhood learning how to read people so I could keep out of harm's way, and now I was using all those skills to put myself in danger, to curate that experience.

Although the compulsive mind was at the helm when I was cruising, it could check in with the critical mind for advice

without releasing control. It would dip into knowledge when necessary—how to avoid being mugged, arrested, molested by someone undesirable, penetrated without a condom. It was like the compulsive mind had enough wherewithal to keep me out of harm's way, but just enough to do its work; too much danger would have threatened my ability to continue the behaviour.

Everything about cruising is an exercise in reading and control. If you're in a public place where everyone might have their dicks out, but you want to be groped only by the men you find attractive, you learn that the environment requires great sensitivity to the subtleties of reading other men as well as keen strategy for how to manipulate the situation—where to stand, what to touch, when and how to bend over or stand up, what body language to send out or retract.

You aren't just working the people around you but must also be keenly attuned to the guy you're with. Is he into this third or fourth guy too, and if so, how do you accommodate that? As an adult child of an alcoholic with a classic preoccupation with people-pleasing, cruising meant a master orchestration of making everyone happy. Sometimes I curated the men around me—I could ensure I'd keep the interest of the man I wanted by hitching a competitor to some compulsive cocksucker I'd seen earlier. I'd literally face one guy toward another and let them play out their furtive dramas. Grab a dick and point it at a hole. That usually worked reliably, though I had to make sure I got the right people facing the correct direction to ensure that those I wanted were left available.

In my attempt to be more careful, I'd try to set rules for

myself—only blowjobs, only men who kissed, only one man at a time, only three men a night, only someone whose features I could see by the light of the moon—but each time I grew more comfortable in a particular scene, the rules dropped away to ramp up the stakes. Risk was the tool by which I disappeared. With the press of a button, fear locked my anxiety behind a heavy wooden door.

Living hard shit is a spiral—sometimes you walk in wider and wider circles, reeling uncontrollably, and sometimes you move in the other direction, travelling toward the centre, where you can see it all in perspective.

You would never know by the hours a week I spent in chat rooms that I wasn't fond of meeting men online. The orgy of dick shots in every profile struck me as too bizarre. I didn't want someone to date just my dick. I preferred to see the face I was going to suck far more than the cock. Eventually, during sex, the prick disappears in some hole or another, but the face, that sticks around.

I didn't have a problem with the promiscuity—I'd always said if you were having sex with one guy every night for four years or different guys, it was the same amount of sex, so what's the big deal as long as it was safe? But I was getting increasingly less safe. Sometimes I'd leave my bedroom door unlocked and invite a man I'd met online to come over and find me "sleeping." Once a guy brought a friend and they smoked crack on my couch, then tried unsuccessfully to get hard. I met men in alleys beside their homes as their wives slept upstairs. I fell

asleep behind the wheel one night at three a.m. after a hot date with a closeted minister and woke up halfway across the yellow line. I began to bareback. A lot. The more I tried to stop, the greater was my attraction to acting out, and the greater the risk when I did.

In my early thirties, I decided to create what I thought was a perfect rule: abstinence. When I walked into a room I no longer wanted my primary goal to be finding a man to sleep with me. I didn't want to turn off my libido, but to act on it differently. I planned to be abstinent for six months to learn how to meet men without trying to bed them. I wanted to see what I had to offer other than sex, and to increase the intimacy in my life. As a safety net, I also allowed myself the option of re-negotiating my terms depending on my evolution.

At first, I masturbated even more. Eventually, a great number of things became clear:

At thirty-three, it's still possible to have nocturnal emissions.

People enjoy you more when you're not drooling on them.

No matter how good it feels at the time, never penetrate yourself with a bar of soap.

I was always looking for men who wanted to sleep with me and not men in whom I was interested: that meant I felt rejected by nearly everyone instead of by a selective few.

By week three, my body noticed that other than a hug and kiss hello with friends or an occasional briefcase against my thigh on public transportation, I didn't touch anyone. Ever. I began a healthy program of curling up with any friend who'd let me. At six weeks, I decided to make out with men without

bedding them since that was practicing intimacy. I went on dates. I didn't fuck. It was great fun.

With all the busyness of cruising put aside, I suddenly had time to hear myself think. The usual fears appeared. I was a failed man; my body was an ironic guffaw. Four months in, I asked myself again why I was so hungry for the muscles of other men. What was it about their bodies that set me apart from them?

The answer I came up with was currency and its lack. I hadn't given my stick arms and legs any value. Despite thinking that men as thin as me (there were a few) were sexy, I didn't think other men thought so. There was a double standard that I used unfairly against myself—skinny boys were hot in their skinny jeans, but I wasn't.

In the fifth month, I met a guy I dated for a few uneventful months. I used my re-negotiate clause to begin shagging him. After five months of successful abstinence, the irony that I had given up sex to realize that I felt undesirable, despite having had a (sexually satisfied) cast of thousands, was not lost on me.

That realization conveniently evaporated when my anxious mind wanted to dim again. When I became that guy who made a rendezvous on a back road between my city and his, when his car pulled up with its headlights glaring, and I did as he'd asked—blindfolded myself and left my car door ajar—then grew rock hard riding the fear as I anticipated the sound of his approaching feet on gravel, and when he finished with me and walked away so that I never saw his face, it got pretty clear

I was making even more dangerous choices than I had been when I was drinking.

One late night, I drove across town to meet up with a twenty-something straight guy at a garage where he worked. The building was classic small-business auto repair. The exterior was run down, with an office for the shop on the far left and a half dozen beater cars parked in the lot.

I was told to knock on the door to the workshop, next to the two large garage doors. From the exterior, it was impossible to know if anyone was inside. There were no windows on the front of the building to show any light. When I knocked, the door opened on a young ox in a ball cap. He was barrel-chested, about five-foot-eleven, with arms thicker than my thighs. He must have weighed well over 200 pounds. He could have bench-pressed me with one arm.

He didn't say anything right away, so I said, "Hey," and gave a nod.

All he did was step back to make way for me.

The door didn't open flush with the floor; it had a foot-high lip that I had to step over to get in. When I passed through, he closed the door, and I noticed that he locked it with a key that he put into his pocket. That was my second clue.

The garage interior was filthy, of course, with a mess of tools and car parts. A Corolla with its hood up was parked on the right side of the room. The back wall was lined with hubcaps; the floor had pieces of the bodies of what looked like three different vehicles. On the left of the garage was an exposed second level, full of junk, and underneath that were counters stocked

with more tools and car parts, the walls lined with stuff. The only window was along the left wall, and it was barred.

I asked how he was doing and he nodded, giving the smallest of grunts, which I thought might have been, "Good."

He regarded me for a second, then looked to the floor, staring straight ahead. I waited for him to say something, but he wasn't snapping out of it.

"Everything okay?" I asked.

"Nervous," he answered. When we'd been chatting online, he'd said he was straight and this was a new thing, so it was no surprise he was uncomfortable.

"Do you want to change your mind?"

He shook his head no without taking his eyes from the spot on the floor he was staring at. "I'll be fine," he said. "Just relaxing."

We stood like this for some time, a couple minutes, maybe, while I watched him struggling with himself. He was a handsome enough guy with a round face, blue eyes. His muscles seemed unreal, packed into his shirt, like thick pillows wrapped in a sheet.

Five minutes must have passed. He barely moved.

"I can go if you're not comfortable," I said.

He shook his head no and lifted a few fingers up, gesturing "stay."

"It's the coke, I did some coke, it … messes my speech."

He spoke like he had three large marbles in his mouth. He was having trouble pronouncing his words. There were pauses in his phrasing, like his tongue went wild for a second and he had to rein it in.

"Okay," I said.

"Just nervous." He looked at me a second. "Never done this before."

"Ever?" I asked.

"Just one guy but we … didn't do much. Jerked him off."

"We don't need to do anything," I said gently. "We can just talk."

He sort of nodded again, slowly.

There was another long pause during which I looked around the room, trying to be casual. "We can just make out, if you want," I suggested.

When I glanced back at him, his lips were moving. He was talking to himself.

I waited another minute for whatever debate to subside, but it didn't.

The room began to feel wired with electricity, like everything was buzzing. The smell of rubber tires grew more intense. The fluorescent lights were brighter, the oil on the floor more black.

"We can just talk," I said. "We don't have to do anything."

His head didn't move but his eyes snapped to me. "I want to. I'm ju-just relaxing. Wired." He glanced back to the floor for a second, then sprang forward, walking to the nook with shelves and tools. Rummaging in the pockets of a jean jacket hung on a nail, he pulled out a pack of cigarettes, removed one, and lit it. He smoked, staring at the floor, mumbling to himself.

I felt invisible, like he was ignoring the fact that I was there. And at the same time, too visible, like I shouldn't be witnessing this guy's crisis. I shouldn't be within it. The door was locked.

He had the key. Nobody knew where I was, and it was midnight. When you're in a situation that is potentially dangerous, you want to convince yourself that it isn't. You think, *Maybe I'm imagining things. Maybe I'm assuming the worst. I can't know what's going on in that guy's head. He's just weirded out. He's probably not crazy. It's the coke making him talk to himself. That could be normal. You don't know what coke can do, except that in movies it makes people violent. Maybe the movies lie. Maybe this guy who is so muscular he doesn't have a neck isn't violent.*

I tried to talk to him about what he might like to do, thinking that if I got him out of his head, he'd be fine. Often the fear of a thing is far greater than the doing of it. But his answers to my questions were brief or he just didn't answer. He barely looked at me, preferring to stare at a spot on the floor ten feet ahead of him.

He took a drag on his cigarette and asked me, still looking at the floor, "What's your dick like?"

When I answered, he nodded. He continued mumbling, this time more intensely. His lips were speeding.

A sort of visceral, animal fear crept up my limbs. I've only experienced that Spidey-sense one time before, in Hawai'i when local friends convinced me to walk on a silver-coloured lava field to see a glowing hole—all of which thoroughly freaked me out—before we moved around to the other side of the opening and realized we'd been standing on a wide foot-thick shelf over a creek of yellow flow. Fear like that is instinctual.

A cold sweat crept behind my ears. If he was going to freak out, it seemed wise to be prepared. My phone was in the car.

There was no back door. I looked around to see if there was anything particularly good to use as a weapon—a saw, a rubber hammer, long bolts, a tire iron on the wall about eight feet away. What did he have near him? Dozens of metal objects he could pick up and use. Often I'd just quickly fuck my way out of a situation I didn't like—the sooner a guy cums, the sooner I get to go home—but each time I envisioned approaching this guy, I imagined him picking up a tool and bashing my brains. The compulsive mind wanted to just have sex and get it over with, while the rational mind couldn't see any way to do it without getting maimed. At best.

I looked to the door of the garage, as if I could confirm that it was as locked as it seemed. Getting the key from his front pocket would be impossible, so where in the garage could I go if he came at me? Was there some way to scramble to the second floor and barricade that door? How might I push him off the ledge if he tried to climb after me? What would be the best tool? If I pushed myself under the car, would he be able to pull me out? Would I fit? If I locked myself in the chassis, would he have keys? Would the doors lock? Could I lock them all before he got one open? And then what would I do? Wait him out?

Because I'd already mentioned I could just go home and he'd replied that he wanted me to wait him out, I didn't want to say I was leaving in case that pissed him off. Somehow I had to get him to unlock the door.

"I might like some pot," I said, "to calm me down too. Do you smoke weed?"

He nodded. "Yeah."

"I've got some in the car. In the glove box. We could smoke that."

"C-can't smoke in here," he said.

"I can smoke in my car. We can, if you want some. Nobody will see us."

"Don't want any," he said.

"Okay, but I'd like some. I'm just gonna go get it. I wanna relax too."

"The door's locked," he said, turning his head to look at it.

"Sure. I'll be right back. Just need a little toke."

He nodded again, then walked to the door.

I watched him pull out his key, insert the teeth, turn the latch, then swing the door open. Streetlight fell onto the oil-stained asphalt in the garage. Calmly and decidedly I walked past him, stepping over the lip.

Unlocking the door to my car, I opened it and crawled in, reached across the driver's seat, as though into the glove box, then came back out. He was standing outside, next to the entrance, ten feet away.

"You know," I said, "I'm bagged, Buddy. I should go. It's probably better we try this another time, when you're less nervous."

"Okay," he said. His face, which had been pretty expressionless up to this point, seemed to fall. He suddenly looked innocent, a kid who didn't get ice cream as promised.

"I'll see you around," I said, trying to sound light and jovial.

Not until I was on the highway did I think I was free of him. I looked in my rear-view mirror to see if he was getting into a vehicle, but the door was closed again on the garage, and there

was no sign of him. Only when I arrived at my condo did I notice my hands were aching from my grip on the steering wheel.

The facts added up far too neatly to ignore: I had a sexual addiction. It was really fucking shitty because I was already an alcoholic. I could handle that. But now I had to admit to being a sex addict too? Totally unfair.

From 2010 onward, thanks to health benefits coverage from the university where I worked, I began to see a psychologist in Vancouver. Gary was a kind of bald uncle, with big ears, handsome socks, and great taste in décor. A sophisticate with an amazing garden, which he used, he said, to channel his own OCD tendencies. The office was neatly arranged, with a grey couch, two unassuming chairs, and a glass-top desk.

The first thing he confirmed for me was that, yes, life is unfair. From that basic premise, we moved forward. He worked with me to not lose my critical self in moments of cruising. Since there were times when my rational self wasn't totally lost, sometimes it shed enough light on a situation to keep me out of danger. Gary tried to teach me to keep my conscious/caring/critical self lit at all times.

He gave me four main tools. The first was to create a mental shell that oversees my life. This greater self, the Observer, would have awareness beyond the immediate moment. The Observer has continuity. The Observer sounded to me like a cheap superhero. I'd no faith in what he was talking about. *Please tell me this guy isn't a flake*, I thought. He explained it twice more and the words made a tidy string of nonsense. He described how I could

create a shell that could see what was happening without getting emotionally attached to the moment. I could gain a greater perspective by maintaining a sense of removal from a situation. I could avoid a knee-jerk cause-and-effect reaction. This Observer, he told me, exists outside the immediacy of the now, meaning it knows the past, it can remember other moments; it is witness to this time and has access to the memory of other times. It holds self-reflection and memory, which are tools for placing the immediate feeling into context and history.

I looked at him in his crisp plaid shirt and tidy blue jeans. These weren't the clothes of a flake, unless he was cleverly disguised. The office seemed legitimate. His hourly price was real. He seemed confident, his blue eyes regarding me, steady and calm.

"So when you say 'detached,'" I asked, "you don't mean dissociated from the moment?"

"No, no. The Observer sees the greater perspective, that this moment isn't the one you've always felt." He raised a hand from the arm of the chair, gesturing to the air around us. "So you don't feel like the current feeling is the only one you've ever had or will ever feel. You can remember other times that were better, you can imagine better times to come. You don't get stuck in that spiral of hopelessness."

I hadn't mentioned my hopelessness. I looked to the windowsill with its cluster of succulents growing toward the glass. The windows of the office tower next door were reflecting light from the sun hovering over English Bay.

"And how do we do that?" I asked.

"We practice mindfulness," he answered.

Definitely a flake, I thought. *But please let him be a flake with tricks that work.*

To get to mindfulness, Gary gave me a device. "I use the bus driver," he said. "I imagine I'm a bus driver, and emotions are the passengers on my bus. Everybody gets to ride the public bus. You let each emotion on. You don't try to make them go away, you just acknowledge them as they enter. You say, 'Hello, Sadness, my old friend. Hello, Loneliness. Welcome.'" Gary nodded to the imaginary emotions, monk-like, beaming.

"I don't think I can be happy about inviting them onto my bus, Gary."

He held up his palms. "They're all equal. All your emotions are equal. You can't let some people on the bus and not others. If you want Happiness on your bus, you have to allow his old friend Abandonment too. Everyone gets to ride the bus."

When I imagined this scenario, I was always a passenger too. Even now, remembering his description of the bus, I'm never the driver. The best I can do is to imagine some dumb guy in the driver's seat smiling as a parade of reckless teenagers step on. I just want to get off and walk. My sense has always been that abandonment, sadness, loneliness, hopelessness, and any of the other lovely fuck-ups I've been entertaining over the years are more like the drivers than the passengers.

"I feel like I'm riding those feelings," I said. "They're driving *me*, Gary."

He nodded. "Okay, but you can choose which ones you pursue. Which you invest in."

"I can choose which feelings I climb on the back of."

"Exactly."

"Like emotional ponies," I said.

That phrase descended from out of the blue. With it materialized an open grassy clearing in the woods of my imagination. A slew of small ponies gathered together, grazing. One spotted brown and white pony—Depression—trotted over to me, lowered its head, and presented itself. I imagined what it would be like to climb on its back and travel along a dark, wicked path through the woods. The image was Disney-fied, but acute. Clearly not a wise choice. And then a sandy pony with a blonde mane offered up his back—Happiness—and I rode him slowly through an open field in the sunshine. He stopped to graze again. The sun was warm on my face. The air was sweet with pollen. Emotional ponies were metaphor magic.

If the metaphor was apt, and Gary claimed it was, I could choose which emotional equines I mounted, which to follow. So with my father's home life deteriorating, for example, and his drinking sometimes even more wildly out of control, I would usually have climbed on the back of Guilt for not doing more, or Depression for how awful it was that my father was so hopelessly committed to self-destruction (which, even at the time, I could admit was ironic). Concurrent with my own self-destructive behaviour, I excelled at work, with its amazing safety-making salary, I'd published a new novel, and my friends and family were being loving and supportive through my own crises of compulsion and risk. I had plenty to concentrate on that brought me comfort. It just never occurred to me that I

could invest in all that goodness without having to wallow in the darkness or feel guilty for not wallowing in the darkness.

Gary was full of what I would normally have thought of as woo-woo advice. But having spent much time with the Radical Faeries, I knew there was some decent shit in woo-woo too. "We're creating new frames for you," he said. "Reframing your experiences so you regard them differently, so they have different effects, or fewer negative effects."

The goal of this particular bus-driver/emotional-pony exercise, he explained again, was to practice mindfulness, a concept that was also unintelligible to me. It was my mind that was fucking up—how was being more within it going to help? It took two visits for me to connect the dots. Being mindful was another way of asking me to practice embodiment, of being more aware of my physical self. I had to move my consciousness into my body. That simple change in language was key— for a kid who grew up hating his body, being asked to pay more attention to the moment-by-moment workings of it, and most especially to not lose contact with what was happening physiologically in times of stress, was a substantial project. My body had been like the city of Sodom—I'd been afraid to look at it, for fear my monstrous lack of esteem would destroy me. The power of self-loathing can sound far more hyperbolic than it feels.

I've now had sex with a couple thousand men. The majority were blowjobs in Vancouver, either at Stanley Park or the Fruit Loop by First Beach. In the last decade, however, most of these encounters took place at my home.

There are advantages to having had thousands of sexual partners. It's a good workout for deep-throating, the fine qualities of which can be improved and maintained only with practice. I became a gourmet of my own desire, exploring the intricacies of what I did and didn't like. I learned how to kiss well by practicing broadly. I became an expert at reading a kiss to know how someone would be if we dropped our pants. I learned a lot about how men are in the privacy of the night, even if those were publicly private moments. I gave a large number of men pleasure through orgasms, tenderness, touch. I held their secrets, most left unspoken.

I got a sober measure of my dick, which is nowhere near the largest around, but far from the smallest. It's neither the thickest nor thinnest, hardest nor softest. It's not the hairiest. It takes longer for it to cum than most, but that means it stays harder longer than average. Given that my parents didn't explain to me what a foreskin was (though I remember my mother explaining how to clean it thoroughly), it was also a great relief to see and hold a small percentage of uncut men. That's still a decent number of foreskins, given that we're working in four digits. My self-evaluated rating of normality increased with every night of cruising.

Numbers help you blend in using averages. Numbers, after a time, are just that. When you've seen as many dicks as I have, you develop a few personal tastes, but the quantity becomes far less important than the quality. Personality begins to shine through.

Despite all the work/sex it took to get to a greater truce with

my body—by the age of forty-one, I had fifteen pounds more on my frame, thanks to the gym; at 150 pounds, I weighed in the "normal" zone for my height; I had shape in my chest, beyond the speed bumps of my ribs; there were bananas in my triceps and apples in my biceps; my foreskin was an asset, not a freak show; my back acne was reduced to an odd blemish or two, and nobody freaked out when they saw it; some people found my body hair desirable—I'd long tried to distract myself from the emotional life contained in all that flesh. I'd been terrified of the world from the inside out. I was terrified of my black cloud. My psyche was a hummingbird, too speedy for predators, trying to outrace panic.

Embodiment, or mindfulness, meant slowing down in many ways. Gary had me practice looking around the room to notice there wasn't a threat. There was nothing here that needed escaping.

The last strategy he proposed was to work *with* my OCD tendencies, rather than try to get rid of them or control them. Gary suggested that I could channel my compulsions; I couldn't make the OCD go away, but I could pick which things I got obsessed over. I could have healthier obsessions. I could watch a TV series instead of cruising on the Internet, replace Grindr with sewing (I love making things with my hands), and anonymous cock for a boyfriend's cock.

I saw Gary for about a year, and when I thought I'd learned enough for the time being—which meant I felt like I was repeating myself without gaining much ground—I decided to take a break and put some of his advice into greater practice. Talking

through my troubles every two weeks gave me an outlet to feel like I was working at it, but in trying to be honest with myself, I realized I was sometimes using therapy to make myself *think* I was working at it. I was still cruising, still disappearing; I just had someone to complain to on a bi-monthly basis.

Stopping for a time would give me a push to enact what I'd learned about disappearing, skills soon put to a great test.

CRUISING TO DEATH

IN THE FALL OF 2011, within months of practicing my therapy homework, I found a boyfriend, which felt like I'd fulfilled much of my life's work. There went the cause of much stress and worry, I assumed. My first date with Patrick was a lovely afternoon and dinner on Granville Island in Vancouver, then a warm make-out session in my hotel room. (I had a free stay at the Granville Island Hotel for the weekend because I was a guest in the Vancouver International Writers Festival.) The evening of our first date, we made out like fiends, but I declined sex so that I would take this slower than usual.

After I said my goodbyes to Patrick, I promptly went online and had bareback sex with a stranger in my hotel room. *That,* I vowed, in the same manner my father did each time he gave up drinking, *was the last time.*

My second date with Patrick took place the next day. He came to my reading at the festival, we went for supper, then we made out again, and it was even better than the day before. With our skinny limbs entwined together on the king-size bed,

I decided he'd be the guy I'd marry. (My therapist and I had also discussed how I could live a more middle-ground emotional life, but I hadn't gotten there yet.)

Patrick and I dated for the first three months using condoms, then got our negative HIV results, which always felt impossible to me, and decided to be monogamous. I was done looking. Waking one morning that fall, I felt my familiar panic return, so I envisioned the dark black absence—Gary had said to acknowledge the feeling—and this time, in the middle of that nothingness, I saw Patrick waiting patiently for me. The black of that placelessness was such a void, he looked illuminated from within, a colourful lamp in the middle of a dark warehouse.

From that point forward, when a man came along with some cruisy energy, I just imagined Patrick in my head and my heart shot out a sure-fire repellent. Patrick was a new object on which I could focus my OCD. I had many quiet months that winter when I got a lot more work done, more easily, because I wasn't cruising online. In the same way that sobriety helps you to leave money in your bank account, monogamy gave me back my free time. I could put in a twelve-hour workday, talk to my boyfriend in Vancouver on Skype at night, and be in bed at a reasonable hour. I worked better and longer weekdays knowing I'd get to see Patrick two or three weekends a month. Week after week of compulsive calm was bliss. Productive bliss.

Dad's ill health was concurrent with that romance. From the start of 2012, my father died in pieces. His decline was like

watching a horror movie in small sections, once or twice a week, short episodes of violence and tension building to a climax. His slow-mo death was an excruciating blessing.

Early in the new year, Dad was admitted to the hospital for difficulty breathing due to complications from his weakened heart. We found out afterward from his ex-girlfriend Rose that not long before this episode, when she'd come to check on him, she'd found him in bed with soiled sheets. She said there had been feces everywhere in his apartment—a trail leading to the bathroom, the bathroom covered in it, an armchair ruined with shit. Because of his heart and poor circulation, which messed up his feet, Dad hadn't been able to get to the toilet soon enough, and he hadn't the energy or ability to clean any of it. My best guess is that he was planning to die in the apartment. If I wanted to be optimistic, I'd say he was expecting to get better and clean his place up later, but I suspect that would be magical thinking on both our parts.

Rose took a look around at the filth and told Dad he had to go to the hospital, but he dismissed this. She convinced him by saying he could go with the ambulance or with the police, a trick that had worked on his own agoraphobic mother years before, when she'd broken her hip but had lain on the couch for three days, refusing to get help.

During Dad's first days in the hospital, Rose sanitized his place. She only told my sister how she'd found him after the apartment was cleaned. Some of his clothes and sheets had to be thrown out, she said, because they were too soiled to keep. The armchair was at the dump. Dad was sixty-two.

That month, he was released for about two weeks, then admitted again, and in February, he was transferred to Ottawa Hospital. My sister had tried to convince him to go to the hospital the second time because one of his legs was in such poor shape he couldn't stand on it for very long. Dad refused. But the next day, the nurse who came to change his bandages persuaded him to go.

My sister and I had known he wasn't doing great, but Dad had tried to keep from us just how poor his health was. He'd mentioned to me that his leg was killing him—he didn't have enough blood flow to heal some wounds on his feet and calves, which is typical for diabetics—but not to what degree it was interfering with his health. He had trouble walking or standing for periods of time and less energy. I knew that much, but we soon found out that the impact of that was far more dire. With nobody making sure he was eating, he wasn't.

After years of my father crying wolf and making excuses for why he was so broke, none of which involved the considerable expense of being an alcoholic or the fallout from that (like: losing your winter coat, losing a bet, losing at pool games for money, losing your paycheque to buying rounds at the bar, losing the loans you gave your friends), my sister and I were reluctant to help him financially. After his release from the hospital in January, Leica began to bring him meals he could freeze. She bought him small household items she thought he could use.

I considered giving him money for extra care, but I was in debt from using my line of credit to buy a condo. And I resented

giving my father anything, after a lifetime of him giving me far too little support and far too much heartache. When I'd started my undergraduate studies, for example, he'd said he was going to give me fifty dollars each week, which never happened. At the end of that first year—when he began a process to declare bankruptcy—Dad invited me to play pool with him. It was the first and only time I got an invite like that. When I showed up at the bar, he asked me if I'd sign a legal document saying that he had paid me the money I never saw because it would help his case. He handed me an envelope of papers to sign before leaving.

Drunks are black holes. I knew this about my father because it played out over and over. Soon after Dad moved out, Rose sold the house my father had significantly helped to pay off, but she gave him only a nominal lump sum, far less than he deserved. Rather than fight it, Dad let it go and lived in poverty. Much of his financial difficulties, I knew, were of his own making.

In hindsight, I could have done a lot more than take his "I'm fine" word for it when I suspected he wasn't. But I wanted him to be fine. I had developed a well-tuned strategy to help keep him from being a burden in my life. In part, that meant caring less—so the disappointments would be lessened—some of that was avoidance—especially when he was at his worst, like when he was found passed out in at least a week's worth of shit and vomit in his trailer—and some was wishful thinking—if we willed him to be better, he might be.

In the Ottawa Hospital, my father admitted that his leg was so painful from rot that he couldn't walk or stand on it whatsoever. The doctors tried to get both his leg healed and his heart troubles stabilized so that he could be released. The longer he was there, the more his body failed, not from any fault of the care, but because his body had hit its limit. Even if they got his leg under control, he had four stents in his arteries already, and a heart that was so big it pressed on his liver, making him retain fluids. His belly had grown round like a beach ball. Too many binges, too much wear from diabetes, too much smoking.

My sister visited him twice a week that winter, never missing a day off. I paid for him to have cable in his room so the TV could keep him company.

Late one Saturday in May, I got a call from Leica saying that Dad's kidneys had now completely failed. Dad would be on dialysis for the rest of his life. It seemed clear that he would never be able to live on his own again, because the complications from kidney failure resulted in disorientation as the toxins built up in his system. Considering his state during his last attempt at living alone, he couldn't be trusted on his own.

Dad was going to have a meeting on Wednesday with his full care team, she said, to decide whether he'd undergo dialysis.

"What's that mean?" I asked.

"He's thinking he'll refuse treatment," Leica replied. "He'd have about two weeks to live."

There is an excited clarity particular to the family of alcoholics when you hear the drunk in your life is dying. It is the potential for calm. Like facing the last, large ugly battle that

is sure to end a miserable war, you look forward to it with a kind of disbelief that it may bring peace. You spent your early life feeling responsible for the alcoholic, because he was never responsible for himself. You felt culpable, because he never was. If you're lucky and you gain clarity, in the later years you try not to feel responsible, not to feel guilty. Then when the alcoholic begins the worst of his decline, the first impulse is to suffer along with him again. Focusing on the peace that may come is a means to find distance, to find a path through, so you might live beyond his passing.

I woke up on the Sunday morning with my back completely out. I couldn't stand or sit or bend over without considerable pain. In stressful times, my body had a bad habit of holding itself so tightly that my pelvis would slowly wrench and mess up the alignment in my spine. I flew into Ottawa that Monday in terrific pain so I could be there for the meeting and Dad's decision.

The afternoon I arrived, my mother met me at the airport and, rather than going to the hospital and leaving my mom in Ottawa with nothing to do, we drove the hour to Cornwall. I wanted an evening on the couch with muscle relaxants.

I wasn't home an hour when I received a text from my father saying that he was leaving the hospital. He was moving in with my sister. That seemed unlikely. I phoned Leica to see what was going on.

"What?" she asked. "What do you mean? He's not moving in here."

"His text just said that."

"Did you call him?"

"He didn't answer."

"I'll get hold of Lara at the hospital."

Leica texted Lara, his social worker, while I drove over to my sister's house.

Lara phoned us back in about half an hour to say that she'd found Dad tucked safely in his room. There was no plan to release him. I was sitting next to Leica on the couch so I could hear Lara talking.

"He's fine. He's not going to be released, but he seems to think he's leaving. Your dad just told me that he sold a painting for 4.2 million dollars. I know this likely isn't true, but I should confirm with you."

"No," Leica said. "That definitely isn't true. If we owned a painting like that, we'd have sold it a long time ago."

"Of course," Lara said, with just enough of a professional chuckle to say she could appreciate the joke. "I don't know what his long-term situation has been like," she continued. "Has your father been delusional like this before?"

"I've never heard him say anything like that before," Leica said. "Never. He doesn't talk like that."

Lara said she'd make sure the nurses knew to phone us if Dad made any move to be discharged. But that didn't seem likely. "I'll go talk to him again before leaving for the night. I'm just on my way out, so I'll stop in and make sure he's settled."

Leica thanked her and hung up. Her face was drained, with a wrinkle in her brow. "Did you hear all that?" she asked me.

"Yeah," I said. "I don't think we have to worry. It's not like

he'd get very far. He can't walk. He couldn't even get himself into a cab."

"Or a pair of pants," Leica said.

"Or a pair of pants. Right."

That thought calmed us enough to get me through the night without the worry that he'd discharge himself.

The next morning my sister, brother-in-law Rolland, and I headed to the hospital first thing. We checked in with the nurse's station to get a report before seeing him. They told us the meeting with Dad's care team had been moved up because Dad was due for dialysis the next night. If he refused treatment, they should establish their course of action before then.

Dad had been clear with both my sister and his doctor that he wanted to avoid dialysis. He'd told two of his brothers the same when they'd been in that weekend. The outcome of the next few days seemed obvious.

Dad's room wasn't far from the nurse's desk. Rolland crossed straight into the room saying to my father, "Hey, Mike, how you doing?" but Leica and I took a deep breath and looked at each other. She smirked as if to say, *Oh well, here we go.*

"Well, there you are," Dad said when we came in. "Hey, Sonny-boy." Dad had gone white since I'd seen him last in the winter. His hair was white. His skin. His lips.

"Hi, Dad, how you doing? A bit rough, I guess, eh?"

"Ye-ess," he said, the way all men from Madoc say yes when they wish it wasn't so.

Leica leaned over him and kissed his forehead. I imagined he felt like paper, tasted like chalk.

"So are you taking me home today?" he asked, looking up at her. His voice was slow, like legs trying to walk through deep water.

"I don't think that's a good idea, Dad. How are you going to leave the hospital?"

"I got it all covered. I sold this painting."

We all had just a second's pause.

"What painting, Mike?" Rolland asked.

Leica shot me a look—what was going to happen?

Dad said he'd sold a painting to an Austrian for $4.2 million, who then sold it to his neighbour for $6.5 million. We asked him a bunch of questions, expecting he'd get flustered and we could then tell him we thought maybe he was confused, but his answers were calm and reasonably detailed. He saw the image in a magazine, he said. The painting had been stored in an attic. He'd been wheeling and dealing for forty years. Under another name. So he could afford to go to Leica's home and live in her basement.

Her basement was unfinished. And there was no way Dad was going to be able to use the stairs.

"I can put in a lift," he said.

He was clear and adamant, so we tried another strategy, not to trip him up but to try to keep him settled in bed. We asked how the money was going to help him; he was still sick so how was he going to get better at Leica's home?

"I found an herb," he said. "It's going to fix me."

"Which herb?" I asked.

"I can't say," he answered soberly. "It would flood the market with too much demand." He happened on the cure, he said, by reading up on his illness. "And I thought, well, if it does this and this other thing, I bet it works for this too. But only six of us in the world know about it. We met online." He looked at us and dropped his voice. "And only one of us can afford it. I had dialysis this morning. They took my numbers for my blood and couldn't believe the results."

Dad hadn't had dialysis.

The three of us tried to counter him, asking questions, but Dad had an answer for everything. They hadn't put his dialysis on his chart. Some nurse he hadn't seen before had come in and taken him down overnight, because they had an opening. She must have been from another ward. The nurses here didn't know he'd gone.

He seemed so reasonable that later, when we were in the hallway, my sister asked me if I thought it was true. Did I think he made millions on a painting? The circumstances were so charged, and he was so calm and convinced, I had the same impulse to believe him. We wanted to believe him.

He hadn't had dialysis, I reasoned to Leica, so he's not thinking straight. It wasn't true.

"But he sounds so sure," Leica said.

"I know, right? But he can't have been dealing in art for forty years. We'd have known."

A nurse walked by pushing a wheelchair. I lowered my voice, because just saying these things aloud made me feel pathetic.

"If it's true, where did that money go? This is the first time he's made any money? And it's millions?"

Leica sort of nodded, watching the nurse retreat down the hall.

"And what does Dad know about art?"

"Right," Leica said, suddenly clear. "He'd better have paid me back by now," she said, with mock-bitterness for having helped him out for so many years.

When I chuckled, Leica's shoulders relaxed. "I could use some of that million," she said.

"He's just desperate. And it's made him delusional, I guess?"

She looked into the room, at the shape his feet made under the covers of the white bed sheet. "He just seems so convinced."

Dad's social worker Lara arrived then. She was bright and warm, with curly ringlets of brown hair around a calm face. She said Dad's care team would meet us now in the consultation room. She could take us there.

Leica, Rolland, and I sat with Lara, Dr McCullough, and Mike the renal assistant, around a faux-wood table in the small meeting room. The chairs were metal frames with square seats and backs in gold vinyl. The walls were beige, with three framed inspirational posters, poorly placed. They were photographs of animals in the wild—a whale underwater, a tiger with her cubs, a hummingbird above a lily—and one word of text underneath. Courage. Love. Inspiration.

Dr McCullough began by reviewing Dad's ailments. Then he gave a précis of what to expect if he underwent dialysis. A

diabetic with kidney failure would have five years if it was just the kidneys, but given Dad's complications, he estimated Dad had one, *maybe* two years. We all agreed, each in our turn, that Dad had said no to treatment while in his right mind. Each of us at the table knew firsthand that Dad had signed paperwork saying he didn't want his life sustained by machinery. Dialysis sort of qualified.

Because Dad had had a coma induced years before, when he was intubated after a collapse, Leica and I had power of attorney for medical care in case that happened again. The decision today, then, was up to my sister and me, but neither of us wanted to answer the unstated question.

We asked what the next two weeks would look like for him. What would that mean?

Given the condition of his heart and liver, Dr McCullough said, he'd have only one or two weeks of consciousness. He'd become increasingly tired, and then he'd sleep and slip into a coma for a week or so. He'd be increasingly disoriented, as he was this morning. And then, essentially, he repeated, he'd just fall asleep.

"I think that's what we should do," Leica said. "It's not what I'd prefer. I'd like to have more time with my father. But if that's what Dad says he wants, I'm not going to disagree with him."

The room felt too beige and cramped for the moment in your life when you tell the doctor to allow your father to die. The words were too easy to say. "Yes, I agree, it's what Dad said he wanted."

The moment felt both not real at all and too real. Unreal but believable, like a dream. I had the sense that the language we were speaking was too simple to carry such consequence. These words were clumsy containers for an enormous moment. They cheapened it, so that reality didn't feel true. I had to bite my cheek and grip my hands under the table to stop myself from screaming.

Everyone around the table agreed that this was the course of action. We stood. We pushed our chairs in. Lara and Dr McCullough collected the papers in front of them. Mike followed them out the door. As we made a parade back into Dad's hospital room, Leica took my hand.

Once we had all stepped into the room, Dr McCullough informed Dad that we had agreed to honour Dad's wishes, to not continue with dialysis.

I held my breath, to see if he'd offer again his crazy story.

"Yes," Dad said, a bit gauzy in the mouth, "I'm tired. I want to go home. No dialysis."

Dr McCullough sat against the arm of a chair, put his hands together, slipped them between his legs, and leaned toward my father. "You remember what we talked about yesterday, Mr Smith, about dialysis?"

"Yeah. I want to go off it." Dad stared at Dr McCullough, his expression drained. They locked eyes.

"And do you remember what I told you would happen?"

"I'd die."

"Yes, that's correct." Dr McCullough glanced around the room at each of us, briefly, to confirm that we'd all heard that.

It was clear. He knew what was happening. "You'll live about a month and then you'll die in your sleep."

"I know," Dad said, and lay back on the bed, closing his eyes.

That evening my boyfriend Patrick texted me to say hello. He was also a professor, but in botany, working on plants in intertidal zones. He'd had a busy day in the lab pulling seaweed apart.

Rather than texting back, I phoned him. My day with Dad was too large for texting. Patrick wasn't checking in to ask what had happened that day or to see how I was doing in crisis. He didn't ask if my back was better (it wasn't). Mostly, he wanted to discuss our plans to be in Italy for the month of June. I told him what was going on anyhow. He hadn't signed up for this when we started dating. Still in the midst of a divorce from his ex-wife, he wanted something casual, and I wanted to get married—my father's death wasn't convenient in that chasm.

On Wednesday morning, Leica and I drove the hour of flat farmland from Cornwall to Ottawa. We were both resolved that this was the beginning of the end. I felt like a sponge that had been squeezed through a very tight wringer but was filling out again with fresh water.

When we arrived in Dad's hospital room, we noticed immediately that he was clearer. His face had brightened. His eyes were sharp, in place of the dull focus of the day before. He was easier to recognize. We later found out that they'd given him a drug that worked on the buildup of toxins in his system. His blood was cleaner, so he had his faculties back.

First thing he asked me was, "How's your back?" He'd remembered how gingerly I'd had to stand up the day before.

Leica and I tried to gauge his clarity by asking questions. He remembered that we'd got him Swiss Chalet for supper the night before but not the stories about his painting or healing herb. He only remembered the things that were true. He had no recollection of the crazy-talk.

"I've changed my mind," he said. "I want the dialysis."

"Are you sure?" we asked. We confirmed three times that he was certain.

Leica ran to tell Lara, who then called Dr McCullough, who said he'd come see Dad later in the day. We spent the morning hanging out, waiting for Dr McCullough to arrive to confirm the change of plan.

For me, there were two fathers in the hospital at this point— the alcoholic fuck-up and the terminally sick father. In practice, we were dealing with the father who was ill, so it was easy to be compassionate and offer a minute-by-minute helping hand. Dad was exhausted. Of course we fetched him plastic cups of ice and bought him braised chicken from Swiss Chalet. Of course we shot the shit about inane things to make the time pass for him. Of course Leica gave him hand cream, and I fetched him a Magnum ice cream bar from the store on the first floor.

But the other father, the historical artefact, was an ass. I'd already mourned him when he'd drunk himself into an induced coma (on my birthday) two years before. Over my forty-one years with him, we'd had his multiple suicide

attempts to contend with, Leica way more than me. We endured his hundreds of sobbing fits, hints at being bankrupt, lies, exaggerations, and slurred phone calls. His reversal on his dialysis treatment felt like another great cheat on what could have been an easier relationship. He could have just let this happen; we'd go through two weeks of a predictable process and then all our suffering at the hands (of the aftermath) of his drinking would have an end. But he had to prolong this process, which pissed me off royally. Up to two more years of his yoyo-ing health and struggles. I didn't wish him dead, but I certainly didn't wish to have another half dozen death scares each time he changed his mind.

While we entertained Dad bedside, two women arrived from physio. Dad was lively with them, flirty and smart-assed, which was way more familiar. He was too weak to walk and could barely stand, but he joked around with the youngest of the physiotherapists enough to make anyone blush. She didn't. Clearly, she'd seen enough of men like him in her time in the hospital. And neither did she shoot him down; she gave as good as she got, which seemed above-and-beyond generous.

Both women were patient with him, coaxing him to take a single step, which he couldn't do. When they placed him again on the bed, he lay back on the pillow with his eyes closed, his mouth limp, exhausted from standing. Within seconds he was sleeping.

We spent the times he was awake trying to fill the silence with chatter until, around noon, Dad was given a sponge bath. My sister and I went for lunch up the hall. When we came back,

he was nearly done, and behind drawn curtains he was getting a fresh diaper put on, so we waited in the hall.

Just then, the palliative care team came to talk to him. Two sober, soft-spoken women had been assigned to visit him because of his decision the day before. They waited a few moments until Dad was robed again, then went in to talk to him behind the curtain.

Lara arrived again to speak with us in the hall about nursing home options, now that he was going to undergo dialysis. She explained, sympathetically, how patients switch their minds all the time like this.

I was distracted, trying to overhear Dad's conversation with the palliative counsellors from behind the curtains. "I don't want to die," I heard him say. "I don't know why I don't want to die; I just don't."

The doctor from palliative, Dr O'Connor, showed up then too. He was a fifty-something, no-nonsense chubby Irishman with an accent. We had to inform him as well that our father had reversed his decision.

"Okay," the doctor said. "Let's have a wag with him and see."

We all entered Dad's room.

"Mr Smith, I'm Dr O'Connor. I'm a palliative physician. Nice to meet you."

He asked Dad a bunch of questions, but by this time in the early afternoon Dad was in pain as his meds wore off, so he was distracted or fuzzy.

Dr O'Connor listed Dad's ailments to him, including cirrhosis of the liver, which we hadn't heard before. My sister told

him that this information was new. Dad was clearly surprised and disheartened.

O'Connor said, in an Irish trill, "Well, Michael, I understand you liked a drink back in the day."

"Yeeeeeeess," Dad answered.

"When was your last drink?" O'Connor asked.

"I haven't had much in the last four years."

"But when was your *last* drink?" he insisted. His tone was assertive. He refused to sidestep a point regarding Dad's history that didn't seem entirely relevant, but I was kind of grateful he was raising it all the same. The doctor was letting him know he was in this hospital bed for a reason.

Dad repeated himself, avoiding the question.

O'Connor dropped his chin in a schoolmarm sort of way, looking at Dad from under his brow. "I understand. You drank a lot back in the day, though you drink less now."

"Compared to thirty years ago, it's been great. But thirty years ago—phhhew," Dad said, blowing out his cheeks.

"A bit rowdy, was it?" O'Connor asked, rolling his r. He was adopting a buddy-buddy tone.

"Oh, it was bad," Dad said. "It was ba-a-ad."

"That must have been hard on your family?" the doctor asked.

The question surprised me. I could feel myself holding my breath. Dr O'Connor wasn't talking to the sick patient; he was talking to the alcoholic.

There was a noticeable pause, then Dad pursed his lips slightly and gave a little shake of the head. "I was more or less alone," he said, not looking at either Leica or me. Some thirty

years ago, my mother, sister, and I were all living with Dad. I was eleven and Leica was thirteen.

"Well, if you want to change your mind, that's up to you," Dr O'Connor said, ending the conversation. "I wish you well, Michael."

He turned to Leica and I, said, "It was nice meeting you," which sounded more like *good luck* than *goodbye*, shook our hands warmly, and left.

The rest of our week visiting Dad was far less dramatic. I took him outside for fresh air, just the two of us, the next morning. We ate an ice cream bar while sitting in the sunshine. It was a spring day with sparrows having choir practice in the bushes. The sun warmed our faces for half an hour until it was lunchtime and I wheeled Dad back in.

Months later he'd tell me that he hadn't been outside since because coming in had been too hard. He'd rather just never go out than have to give up the sun again.

I spent the following day packing up my father's one-bedroom apartment. It was clear, Leica said, that he wasn't moving home again. She was terrifically practical. On a limited income, Dad would be better off not paying rent. The hospital would charge him every day he was there, once they moved him out of care and into the "holding floor," as they waited for a retirement-home bed to open. So to save money he didn't have, we would move all his things into Leica's storage. Since she'd done all the work visiting and running errands these last months, I'd offered to do the packing.

I wasn't thinking ahead at all, so I went to the apartment alone. Never under any circumstances will I ever be that stupid again.

Boxing up the food containers—the canned beans, the pasta, the half-used bags of rice—was beyond depressing. Each item was something he'd bought but which he'd never eat. I wondered, *Could we use this food to cook for him, so that at least he'd get to use up what was here?* The idea that he'd never finish the food in his cupboards seemed obscene. Wasteful. He was still alive, in the hospital, in that physical place. The unused boxes and cans of food were an ugly marker of how much he'd lost. He'd never eat in his kitchen again. He'd never eat the brown beans in this cupboard.

There was an intimacy, being in his home, that I'd never before experienced. It was my first time in that apartment. The building was a boxy two-storey walk-up, a fixed-income residence with narrow cinder block hallways and old windows. Dad had had a place on the second floor, but after a year of asking he finally got moved to the main floor. A resident had complained to their manager that she'd found him passed out on the steps, which gave credence to his "I have to crawl up the stairs" issue—they'd moved him before they got sued.

I wasn't accustomed to spending time at my father's place. I had when he lived in Cornwall, but in the last dozen years, he'd more often than not drive the hour into town to my sister's. Our visits were short and on his terms. He'd drop in for an hour, maybe two, and then drive back home. Decades had passed since I'd eaten a meal at his place or since I'd so much as

opened a cupboard drawer or the fridge. I was trespassing in a space I'd never been invited into.

In small domestic ways too—that food in the cupboards, his cassette tapes, the colour photocopies of his parents framed and hanging on the walls, the daily intimacies of the kind of life he was living—my father had shut us out. Now the markers of his home life were mocking him. Choices he had made about his health and drinking had pushed aside even the everyday life he knew.

Having struggled for years with my own ever-evolving addictions, this was heavy shit.

In the large storage closet in the centre of the apartment, where he kept his tools and fishing gear, I found a box of miscellany that included photo albums. They held pictures of my sister and me, his parents, some friends, and ex-girlfriends. In amongst the photos was a newspaper clipping of a drawing I'd had published for a weather column when I was about eleven. In between the pages of the photo album I found a story I'd written in grad school that Dad had asked to read at the time, a dozen years before. I didn't have a copy of that story—I barely remembered it.

Dad had moved more than a dozen times over the years, sometimes leaving with what we thought was little more than the shirt on his back. He'd been thrown out, or left in a fit of drunkenness, on a number of occasions from a number of women's homes. It didn't seem possible that he could have these mementos still. All this time, from one apartment to the next, he'd managed to bring the photos of us with him. I wept

for an hour over them, beside myself with a feeling I can only describe as relief.

I didn't see my father again until after I'd returned to Kelowna, taken a difficult trip to Italy with Patrick, and on my way back east, made another stop in Ontario, solo, for a visit in June. That visit, thankfully, was uneventful. Dad was still in the hospital, his leg was still bad, and his dialysis meant that every three days his mental fogginess was cleared and he enjoyed a day or so of rational thought.

In the large cafeteria on the main floor of the hospital—with its wooden walls and 1970s orange décor—Dad and I sat eating our usual ice cream. He'd wanted to get out of the room. When I mentioned I'd just come back from Italy, he asked with whom I'd gone.

When I said Patrick's name, Dad gestured to the room, asking, "Well, where is he? Why isn't he here?"

It was the first time in years he'd asked anything about my love life. I could tell him things—and sometimes did—but if ever he had a question, he'd wait to ask my sister. He didn't want to talk about it with me.

"He had to get back for work," I answered.

"Well, you could have brought him. I'd like to meet him."

Dad took a bite of his ice cream. He didn't notice it was running down the side of his hand.

The moment I said goodbye, I stood by his bed and we looked at each other, both of us choked up, silent. My eyes pooled,

his grew glassy. It was the clearest we'd ever loved each other, without the sullied mess of our past, I think, and so neither of us needed to say it. I wished the world for him in that moment, a much different world than the one he'd been given, and he saw it all in my face and knew it was true.

I kept in touch with him mostly by text or messages from my sister over the next two months, until the end of that September when his leg got worse. My own mental health took a nosedive in that time.

Once back in BC, I made plans to spend six weeks at a retreat with Patrick for half of July and August. Our great love affair wasn't going well, though. He wanted more affair and less love. Patrick had been a great boyfriend, but he was a rotten match for me. My "enthusiasm" scared the pants back on him so that, by June of 2012, I gave him an ultimatum: if he wasn't crazy about me, he should say so and end it.

He asked for a six-week break.

In those six desperate weeks, which were a kind of sullied summer bonus to me since they were freed up, I took full advantage of the weather. I went to a three-day outdoor music festival, camped at Johnson Lake, with the clearest water in BC, went horseback riding, swimming, and canoeing, and a few mornings a week went cycling to the top of Knox Mountain. I ate goat milk gelato three days a week and bought new clothes whenever I felt like it.

Six weeks later, when he was back from his work retreat, Patrick broke up with me. It was an exceptional split, given the care we took with each other. We both cried and hugged and

tried not to sleep together one last time, which we didn't, more from my resolve than his. After nearly all was gently said and superlatively done, I asked, "If we're breaking up this way, with this much kindness and care, isn't that a sign we shouldn't be breaking up?"

Patrick sighed and said, "That doesn't change anything for me."

I was devastated to be single again. All my eggs had been in Patrick's sizeable basket. When you have serious abandonment issues and the guy you think is the love of your life—who you've waited the last twenty years to meet—then breaks it off with you after nine months, it's like picking up a sledge hammer and whacking the wooden beams on your emotional roller coaster. Comingled with the heartbreak was a healthy terror of what my future nights might look like. I was sick to think my sexual compulsion might all start up again. I went back to therapy immediately, to try to dam the tidal wave.

I had surprisingly little sex in those first weeks, mostly because I spent the evenings sobbing. I sobbed over ice cream, sobbed while camping, sobbed cycling up and down Knox Mountain. Everything that I enjoyed doing I did through the gauze of sadness. For the first two weeks of September, I went to work each day, taught great classes—my student evaluations at the end of that year would be my best yet—and once home, was barely able to move off the couch. I ate anything in the fridge that could be eaten raw or heated in ten minutes. I spent the better part of most nights trying to calm down the sobbing long enough to call someone.

When depression comes, it feels like you've always lived it. The emptiness is so acute, it can convince you that you've never had a reprieve from it. You lose sense of your own history; it colours your memories, so that the depression is a dark grey tint that infects everything you know. Study the images of your past, and the scrim of depression will convince you it was always there.

The blackness returned, an impenetrable emptiness, but in place of the typical feeling of hovering over me, this time it enveloped me like a dark cloak. The sensation was beyond reason. Everything felt emptied out, like the inverse of animism. There was spirit in nothing. At home, I felt immobile. I could barely breathe, abandoned by more than parents or joy or love, abandoned by the will to live, abandoned by every little thing that lives. Cut from the living world, that darkness was a weight beyond sense.

At its height in early-September, I spent about a week phoning friends at all hours of the day, weeping for fear that I might kill myself. I gripped the edges of the couch, willing time to pass so that I might survive long enough to get out of the black cloud. I tried hard to practice what Gary had taught me: to be aware of the moment, be the observer of it, and know that my life is larger than this particular feeling. However overwhelming.

I had to tell myself I'd be forcing my family to deal with my death just as Dad declined in the hospital. I couldn't imagine dying before my father. My suicide would quickly ruin him. I couldn't imagine putting my sister through two deaths.

In the second weekend of September, I took an urgent trip to Vancouver to see both my therapist and my doctor. I made my GP put me on an anti-anxiety drug, an SSRI, that I researched thoroughly. Having resisted pills for decades, I was sick of going through stress-loops and depressions once a year. I realized, talking with my sister who had been on Paxil, that her symptoms were identical to mine. I had about six different symptoms that I'd given six different names, but Leica had identified them as only one. Anxiety. When I started to identify exactly what it was and how it worked, I began to make sense of my compulsion. My OCD was partly a way to drop out of feeling to avoid the speediness, fear, and tension of relentless panic.

I entered Gary's office for therapy that month to try to contain the inky spread of this hopelessness. I had a hard time even looking at him in his button-down shirt and crisp blue jeans. I was in a state of supreme detachment, resistant to being present. I had arrived in his office only by putting one foot in front of the other and not thinking about what I was doing. Every moment felt flattened or drained; it was like eating a meal rendered tasteless by a cold, but the lack of sensation infects all of your senses. Everything was dull.

I sat on the grey felt couch as Gary took his usual position in the chair opposite. He crossed his legs and placed a small yellow notepad on his knee. I reported to him about my recent days of feeling deeply suicidal and depressed. He asked questions, and we talked for some time about my blackened mood.

He leaned back in his chair and said, "Can you do this for me? I want you to put yourself in that loneliness. Imagine that deep black place; feel that feeling."

I looked around the office at his desk, the box of tissues on the coffee table, and the large abstract painting on the wall behind him, unsure.

"You're safe here, Michael."

"I don't know if I am," I answered. "I don't want to be in that feeling. I don't trust myself with it."

Gary gestured to the space around us. "There's nothing in this room that is going to harm you. Look around. There is no threat here."

That insight might seem obvious, but I found it surprising. The clear glass water jug on the side table, his tidy desk, the books on his shelves, and the sisal carpet under his coffee table, all of it was routine. The room was safe, of course. I was the threat. My thoughts were the threat.

"Okay," I said, nodding slowly.

"I want you to be in that blackness. Feel that place."

I closed my eyes and opened my mind to the feeling. I was quickly within the grief and panic. It was a heavy fabric of unfeeling, a blackened room wrapping around my body. I sobbed into my hands on the couch for a long time. In no small way, I was relieved to be sobbing in front of Gary. Few people saw the fierceness of it. I hoped he could save me.

"Now I want you to know," Gary began, his voice calm and gentle, so that I could see he was about to put perspective on this moment, to help move me out of it, "that this feeling is

never going to leave you. You will always have this feeling. It's inside you. And there is no getting it out."

The cruelty was sharp. His words were a slim bright blade in my chest.

I glared at him, incredulous.

"Why would you say that to me?" I asked.

He leaned back in his chair. "Because it's the truth," he replied without so much as a shrug.

I pulled a Kleenex from the box and wept uncontrollably, blubbery and shaking. A third of me felt safe enough with Gary that I could be this ugly, another third allowed myself to cry as hard as I felt to reveal just how threatened I was, and the last third was to demonstrate the effects of his cruelty. I wept with the relentlessness of the feeling, I wept for the years I had already carried it, and the years Gary said I would have it still. From the bottom of a tall, tall silo of hopelessness, I wept in a kind of frenzy, as I had as a seven-year-old, alone in my bedroom, terrorized by life, thinking I might lose my mind from the horror of being alone. My head rattled with grief.

Gary didn't say a word. Some ten minutes later I calmed down enough to try to catch up to my staccato breath. Gary had his arms along the sides of his chair, patiently waiting. Three fingers held a pen against the chair fabric. His wedding band was silver and dull in the light.

He said, "Now I want you to see, Michael, that you can live with this feeling. That it passes. You can observe the feeling and let it pass. Now you *know* that it passes. And that you will survive it." He turned his free palm upwards. "In fact, you've

been surviving it all these years. And it hasn't harmed you. It's *just* a feeling."

I took another tissue from the Kleenex box and pressed my face into it. My nose was coursing with snot.

Gary continued. "It can't do anything to you. *You* get to decide how you act. This feeling can't make you do anything you don't want to do. You're safe, even in this feeling."

I wiped my face. "I'm safe," I parroted, thinking that over. "Even in this feeling."

I glanced at the room again, at the closed door, the lights, and the sky outside, blue with two clouds in the upper corner of the window. Gary's hand still held the pen against the edge of the chair.

"Can I write that down?" I asked.

That week, my Kelowna buddy John called to check in on me after I'd returned home. John's a counsellor and perhaps the steadiest man I know. I told him about my visit to the therapist and how Gary had worked with me on feeling safe.

John suggested I try his strategy. "What brings you comfort?" he asked.

"Comfort?"

"What brings you comfort in the world? Where do you go for comfort?"

I hadn't a fucking clue. "I don't have a clue," I said. "Ice cream?"

"Okay. Food is a comfort, sure. Do you have something more permanent maybe?"

I drew a blank. "What do you use?" I asked.

"I use my house. My home brings me great comfort."

"Oh," I said, looking around my condo. "Yes. Mine does too."

There was an echo in that moment to sitting on Gary's couch, realizing that nothing in his office was harmful. Certainly not on its own. I had grown up with parents who had a hard time paying all the bills, with a mother who grew hysterical when my father drank our money away or rolled another car. Home had never been a safe place. When I'd moved into my condo, it was three years old but had never been lived in. I was the first owner. *No ghosts*, I had said to myself. I was very conscious that I bought a place without a history and so was making its history each day. When I began cruising in this place, I was cognizant of the fact that I was adding that bad vibe to the mix.

I realized from talking with John that the choices I made put me at risk, but nothing in the condo was a danger to me unless I gave it the power to be. Including myself. I had thought for years that I was my own worst enemy, but this framing gave me a means to conceive of how to change that.

My condo was safe; I was safe within it. If I stopped being reactive to non-present threats, I would remain safe.

Concurrently that September, my father's health took another nosedive. His leg was in such bad shape that the doctors said either it went or he did. They couldn't get the blood flow to improve enough to make the antibiotics work on his leg. It had so much rot that it was now threatening to kill him via his bloodstream.

On September 26, I posted on Facebook:

> Dad's full care team meets today to discuss his options for the days to come. For those who have been asking, he doesn't want the amputation, because odds are against him surviving the surgery. So today we look at what are the best strategies, and what is in store, with a man whose foot is rotting black.

With all the complications from his poor circulation, failing kidneys, blocked arteries, cirrhotic liver, plus the poison in his system from the leg rot, the care team told my father and sister that his chances of surviving the surgery were compromised. Dad would be lucky to leave the operating room still breathing.

My father didn't think it was worth the risk. Better to have a few days left than none at all.

Leica and I told him we thought otherwise. A month of extreme pain wasn't much time left compared to the pain-free years he might have if he survived.

By the next day, he'd changed his mind. My sister told me that when Dr McCullough walked into the room to see what had been decided, Dad greeted him with his wry sidelong grin.

"Morning, Doc," he said, chipper. Then he squinted his eyes, and asked, "Do you have your knife sharpened?"

I was on a plane to Ottawa that day, September 27. Luckily, I had a great teaching schedule, Tuesday evenings and Wednesday mornings, so I could leave town and be gone for six

days. I flew first thing that Thursday, with a black suit in my luggage, just in case.

I stayed at the Rotary Club hotel, which offers cheap rooms so that families can have affordable accommodation close to the hospital. I'd decided to stay there so that I could be with Dad all day, maximizing my hours and giving my sister a much-needed break. She'd been travelling to Ottawa on her two days a week for more than six months.

As I walked across the parking lot, then entered the hospital on that visit, I felt a kind of otherworldliness to the day. Disbelief, maybe.

When you're visiting the dying, everything is layered with narrative—this is the route that takes me to the hospital, these are the bills I use to buy us an ice cream bar, these are the insignificant words I say. You feel compelled to share the narrative with everyone—if only they knew what a struggle you're immersed in—but passing the smokers standing beside their IV poles in the courtyard, you realize everyone is in their own crisis. It's lonely-making, knowing that every moment in this drama is only yours.

These automatic doors, I observe, open onto the hospital I am entering. This is the hallway with a man carrying flowers, two boys who hold each arm of a teddy bear, a young woman with dreads falling out of a blue toque. The elevator is more than an elevator. The buttons are loaded with import. They've been pushed by so many sick people—I use my knuckle to press them—they've witnessed a long history.

Each person in the elevator is in the midst of her or his own story. This senior in slacks silently passing a fast-food cup and straw to share with his daughter in a flowing dress, this man with his hands bandaged, this young kid holding the dress of a woman who's trying not to act preoccupied, to pretend for her son that this is just another day. The son stares at the man's hands. They begin to talk.

Everything feels connected, even causal. My father in that bed up there on the third floor causes me to pay for this ice cream, push this elevator call button, smile warmly at the people entering, watch the child speak with a man in bandages about an accident with fire.

We witness these moments while they are happening, making of them a narrative, a small whispering voiceover in our heads, because we want a sense of order, want to believe that random shit can make sense.

When I arrived at the hospital that evening, Rolland was sitting on the windowsill with one leg hanging over the ledge. Leica was in the chair by the bed. Dad looked over as I came in the door.

"Well, look what the cat dragged in," he said, trying to sound animated, but he was so tired the expression on his face didn't change. "What are you doing here, Mick?" Leica had told him I was coming. He was trying to make a show of it.

Had I not seen Rolland as I came up the hallway, I wouldn't have recognized my father. Leica had warned me he looked eighty, so I was prepared, but there was little left of the features I knew to be Dad.

"I thought I'd take a look at you while you're still in one piece," I answered.

"Oh, yeah," he said, his voice lilting upwards, then down again, pretending there was a question in there which he knew the answer to.

Dad's skin was so translucent and thin, the blue veins shone through his temples, along his wrists, and across the back of his hands. He looked as if a blood-crazed vampire had drunk so ferociously, he'd taken everything—blood, muscle, and layers of skin. His body was a brittle husk. A month before, he'd turned sixty-three. It seemed impossible that anyone sixty-three could look this old.

I took off my coat and hat and approached the side of the bed to say a better hello. Dad's body heaved, everything tensing. His bony hands clutched the bedrail. He pulled himself onto his side, his mouth hanging open for a second then clamping shut.

"What's going on, Dad, are you okay?" I asked.

His lips were pressed so tightly they made a blue line.

"Dad's been having waves like this all day," my sister said. "They just keep coming."

"Wow," I replied, without a clue how else to respond. "That's shitty."

The episode lasted thirty seconds or more, with Dad struggling for breath through his nose. As he gripped the edge of the bed, his arms looked like wet nylons hung over a shower-curtain rod. He was all bone.

As his body relaxed and settled back into the bed, he said, "You bet it's shitty."

"We've asked for more meds," Leica said, "but they have him on a maximum dose. They can't give him more."

Dad was in a private corner room. He'd already shared a room in recent weeks with a man who had died in the night, then another man who was mute but bawled in pain for hours at a time until he too died. "That explains the noise he made," Dad had said. "I felt sorry for the guy, but fuck if anyone could stand to listen to it all day and night."

Pre-surgery, they gave Dad some privacy so he could rest better. The room was like every other, with a steel-railed bed, two uncomfortable vinyl chairs, a TV suspended from a bendable arm, and wood-veneer side tables with metal legs and framing. There was an IV drip next to the bed and a wheelchair in the corner.

Leica stood and gave me a hug. She said they'd been waiting all day for the staff to walk in and take him to the operating room.

"Do we know why they haven't?" I asked.

"They *were* waiting for tests to come in. But they can only do it when the operating room is free. Dad isn't on the list. They have to fit him in when they can."

"I just want this to be over," Dad moaned, gritting his teeth. He looked angry and incredulous and completely lost. "They're just going to keep me waiting here all night?"

He stared at the ceiling for a few seconds then closed his eyes.

We sat with him that evening, trying to distract him from the waves that gripped him every two to three minutes. It

wasn't easy to find subjects fascinating enough to distract the attention of a man who was going to lose his leg. It was like chitchat Olympics, and the leg was winning.

Eventually Dr McCullough came by to say that Dad's fluids were too high because of the pressure on the liver. They wanted him in better form before the surgery, so they had to drain his stomach first. They were leaving it for the night.

"So does he get in first thing tomorrow?" Leica asked.

"We'll see. This doesn't put us ahead at all. We still have to wait till the operating room is free. This doesn't bump any scheduled surgeries."

"Oh, no," my father wailed. "I can't do this all over again."

"I'm sorry, Mike. We're doing our best. I'm going to get you in as soon as I can. We don't want you suffering."

"Can we do something about the pain?" Leica asked. "He can't stand it."

"He shouldn't be feeling any pain," Dr McCullough answered, looking to Dad.

Leica clarified, "He's been shaking with it—"

"It's not *pain*," Dad interrupted, spitting out the words. "It's *fear*. I'm fucking terrified. They're going to cut off my *leg*."

"You're having anxiety, Mike? We can get you something for that. We want you rested. I'll prescribe some diazepam. They'll bring it in shortly."

After Dr McCullough said his goodbyes, the three of us spent the evening trying to keep Dad calm so that he might sleep. Around ten at night, Leica, Rolland, and I went back to the hotel. They'd decided to get a room too, in case Dad went

in for surgery first thing in the morning. The walls between our rooms were so thin I was sure I'd hear the bristles scrape as they brushed their teeth. I was relieved that they were next door because I couldn't invite anyone into my hotel room without them knowing.

I was jetlagged, still three hours behind, and wide awake, so I did what I always did when I was stressed out—I logged online. I chatted with a few guys, mostly the entertaining Don, a silver fox with great arms and shoulders in his photos, and at the same time with a younger guy, Adam, who looked to be in his early thirties, with the prettiest blue eyes and a rugby-player body.

In an effort to be more present—to turn off my zombie hunger—because I was terrified of what acting out might look like in these circumstances, I told both men why I was in town. *My father is having his leg amputated*, I wrote. Seeing the words didn't help it feel more real. Language became unplugged. The containers of the words couldn't hold the complexity or scope of that experience.

I chatted for a good twenty minutes, alternating between both men. My automaton was in gear, whispering its urgings. If I was quiet, it reasoned, I could leave the hotel, and my sister wouldn't know. Years of soft-footing back into my parents' house at any hour of the morning when I was a teenager, coming home way too late without waking anyone, had made me an expert in sneaking out. Being gay had made me an expert in reading a situation and anticipating. Cruising had

made me an expert at finding alibis. If Leica caught me by accident, I'd tell her I couldn't sleep, I had jetlag, so I was taking a long walk to deal with the tumult of the circumstances.

Once the automaton gets the idea in my head to get sex, it's hard not to follow through. There is a sense of inevitability to it all. The automaton offers me an escape route from an emotional prison, and I will sit there suffering, wondering why I'm not taking that route. If not now, I'll eventually act out, so it's better to relieve the cruising energy when I'm still alert, rather than when I'm more tired, more desperate, and more likely to make worse judgments and decisions.

I doubted I could land Adam, because, despite making him *lol*, I just didn't have confidence anyone with that body and face would be interested in this set. I wasn't going to put myself at risk of rejection. I sent Don an invite to "hang out." I knew what to do with older top guys. Their dominance made them easier to play—there's plenty of the predictable in that role.

He was interested, he replied. But would I be into a threesome?

"With whom?" I asked. We were getting along well enough for me to use proper grammar.

"Hope you don't find this weird," he wrote back, "but you're already talking to him. In another chat."

I wrote back, "Busted."

By crazy luck, it was Adam.

They picked me up in a blue Lexus. It was raining outside, so I shook both their hands after I climbed into the back seat. The car was so nice, I was afraid to get it wet. *Oh*, I thought, *these*

guys are going to turf me as soon as we get to their place. I was sure that, after we were out of the car, they'd get a better look at me and call it a night.

To distract my negative storytelling, I asked them personal questions. They'd been together about a year. They lived on the other side of town and were just returning from supper at a nearby restaurant. (We'd arranged for them to drive me to their place in Wellington, and I'd take a cab back afterward.) Don owned the car. Adam was in school for something like human kinetics or massage therapy; he was a brainiac, on a scholarship. Don did something equally smart, with money, I think.

Once at their place, we chitchatted during the ride up the elevator. I made jokes, expecting them to find me out at any moment and say no thanks. I let the thoughts in my head race and my exterior remain calm. *Don't react to it*, I told myself.

Their condo was handsomely furnished, with dark blue walls and a big lovely dinner table, which always impresses me. You don't have a table like that if you don't use it. Dinners are civilizing.

"Would you like a drink?" Don asked.

"I don't drink," I admitted.

"I don't either," Don said, "but Adam does, so we have wine. You want some sparkling water?"

"I can have tap water. I'm not that fancy."

Adam chuckled.

Don said, "You don't have to be fancy to have sparkling."

"Okay," I said.

I smiled warmly, but my brain was racing, determining that these guys were friendly and bright. There wasn't much I could get away with, I thought. They were going to know I was a basket case. Maybe, I hoped, they would just think I was nervous.

As I stood in their living room, Don clearly tried to make me comfortable while Adam smiled sweetly, showing his dimples and blue eyes, following Don's lead. I felt awkward because my body didn't know where to be (it was out of sorts to find itself here, far removed from the hospital). I heard Gary's voice reminding me not to react to this feeling, just to notice it and let it pass, trust that I'd be fine in the moment-by-moment. In short, don't cause my own problems by freaking out or saying the wrong thing. I tried to hide my lack of confidence; I didn't think that revealing how I was melting on the inside would help me get laid. My outsides, I reasoned, could be a great still shell to hold the slosh in, so nobody need see it.

Think of something clever, I told myself, but I had nothing. So I chose something sweet. "You've got great taste. I love your art," I said, turning to Don.

"That's the ex-boyfriend's. I kept it."

We chuckled and I said, "Maybe I should ask for his number," to which Don laughed aloud.

"He hated it," he said. "You're in the right place."

They invited me into the bedroom. We lounged on the bed, making out, slowly removing articles of clothing. The sex was straightforward. Both had huge, cut porn-star dicks, of course, the length and girth of salad cucumbers.

I kept hoping I'd get fucked by Don, who was clearly the toppiest, though I'd have been happy with Adam's dick too. Each time Don ran his cock up the crack of my ass, I tried to manoeuvre him into the soft crevice of my hole, but he slid his hips forward, sliding along the perineum. They must have made an agreement before I arrived, because nobody got fucked—that energy was completely off the table.

I wanted to be taken, to disappear into their flesh, but couldn't get my mind to step outside for a break. The sex was odd for me because I didn't disappear into it. Don wouldn't tease my hole, both of them were very sweet, and my mind kept talking to me about being inadequate but trying to not let on. Eventually, after a variety of triangulations of body parts, we all came and lounged on the bed. Don and Adam kissed for a long time afterwards, for a couple minutes, while I watched.

Then Don pulled me down between them and we lay there, puppy-piling. This was Adam's first threesome, they told me. That kiss, then, made sense: they were communicating their care for each other. Adam was only in his late twenties. They decided to have a threesome because Adam hadn't had one before and he was curious.

Everything about that evening was refreshing. They were kind men; the sex wasn't detached or full of porn tropes. I was more present and aware of what I was feeling, and we didn't do anything dangerous. The evening was a success and a relief for my rational self, and a disappointment for my stress-case cruiser. I had the rare sensation of having anonymous sex that

hadn't allowed me to disappear. I wasn't sure I liked it; I was as awkward as a teenager.

After I was dressed, the boys said the nearest cabs were three blocks away. It took me twenty minutes to get to the main street, because as soon as I was on the sidewalk, I logged onto Scruff on my phone. I sighed with relief when finally a cab turned the corner with its overhead light on. I flagged it, and on the drive home, chatted on my phone with a nineteen-year-old kid who told me arrogance was sexy.

Bedtime was about two a.m. that night, so the next morning I was profoundly tired. At eight a.m., it was only five a.m. on West Coast time. Leica and Rolland texted to ask if I was ready to walk over with them. We'd told Dad we'd be over first thing in the morning. I threw on fresh clothes, brushed my teeth, and washed the smell of dick out of my beard.

On our walk to the hospital, I ate a small bag of trail mix and an apple. Crossing the pavement, I was wading into guilt for having snuck out to cruise the night before my father had his leg cut off. I tried to give myself a break because I was doing a decent job, considering. My thoughts were like lightning flashing between two metal poles.

"Did you sleep well?" Leica asked.

"I had trouble falling asleep," I said. "Jetlag, I guess. So I got less than six hours."

Dad was still fast asleep when we arrived, his breakfast tray untouched. When he woke, he was only a bit calmer. He'd barely slept, he said. Every time he heard a noise in the hall he

thought they were coming to get him for surgery. When the nurse arrived to drain his extended stomach, he was panicked that it was time for surgery, then heartsick that it wasn't.

Before surgery, Dad had had nothing to eat, but they gave him applesauce in the evening when it was clear he wasn't going in. Then, on the second day, he also couldn't eat before surgery.

The morning and afternoon were about as stressful as you might imagine if you were waiting for someone to show up to take your father to surgery where they would cut off his leg, a procedure he might not survive. I took a few short walks in the hallway to have a break from the intensity of trying to be optimistic when at every moment I was a wreck of nerves. My stomach hurt, my hands shook, I had waves of heat rolling through me.

During our efforts that morning to comfort him, my father said, "What kind of man am I going to be if I can't walk?"

"You can't walk now, Dad," Leica said gently. "This way you won't have any pain."

"You worked with Gerry for years," I added. "He only had one leg. You didn't think anything of it." His old friend Gerry had lost his leg to a train when he was twelve, trying to jump it. "This is the same thing, Dad."

"Yeah, but he had a prosthetic. He could walk."

Dad's amputation would be high above the knee. Given how fragile he was, the doctors agreed that it wouldn't be wise to try to save any of the leg, because nobody wanted to see him undergo a second surgery if the first wasn't a cure. They wanted

to eliminate as many risks as possible at one go because Dad didn't have a lot of chances left.

"It's better to be alive without a leg," Leica said, "than dead with both of them."

I laughed. "That's true."

"I guess you make a good point," my father added.

Later in the afternoon, Dad rearranged the hospital sheet and yellow crocheted blanket a number of times, throwing them forward and back. I sat at the end of his bed on his left side by the bad leg, which I hadn't yet seen. He'd always had it covered when I was there. Eventually, Dad took the blankets off of it completely. There was a quality to his fussing that didn't suit him, which puzzled me.

What was he doing? It seemed he wanted to show his leg to me. At first I wondered if it was to gross me out—to make me uncomfortable—though there wasn't much benefit for him in that. Maybe it was a way to show the leg to us before it was removed, like a last viewing—*here I am, still whole*—and to have company in this situation, maybe to put an end to the secrecy; it was something we talked about but never witnessed. Or maybe it was from some form of pride, so I'd believe him that it really was as god-awful as all that. This time he wasn't just faking it. The obvious never occurred to me, that his leg hurt so intensely it couldn't even support the weight of the fabric. After so many visits, either he finally felt comfortable enough with us to reveal the wounds, or the pain was so great that he no longer cared.

The sight of that leg was unimaginable. The chief issue was an effect of the diabetes and his poor circulation, which prevented sufficient blood from reaching his extremities. His heart couldn't pump that far, so the sores on his body wouldn't heal. Instead, they rotted. I had anticipated that they'd be open wounds, moist, red, and concave, but they looked like cavities filled with dirt. The largest sore on his foot was about an inch and a half in diameter and seemed topped up with brown dirt that had dried and crackled. There was nothing in that cavity that looked like it could come from a human. It was the absolute dried rot of the dead pockmarking a living leg. I don't know exactly what the cavities were filled with—blood, flesh, pus; it's the kind of thing I'm better off not knowing—but it looked like some kid had dug out a number of holes and filled them up with mud from the garden. Then forgot to water them.

Finally, in the early evening, they came for him. Leica and I both said goodbye trying to strike the right casual tone to diminish his anxiety inflected with *You know I love you.* They wheeled his entire bed out to bring him to the ER. Every nurse on the floor came into the hall to touch his arm or his shoulder or to grip his hand. Everyone wished him luck with such warmth and care I thought I might sob with gratitude. In those gestures from the men and women nurses alike, the way they looked at him, I could see that Dad had charmed them all.

We followed the bed down the hall toward the first set of doors. When his nurse from the day shift realized what was happening, she charged from the other end of the hallway and

flew through the doors behind us to catch him before he was taken through to surgery.

"God bless you, Mike," she said, placing her hand on his arm. "We'll see you again. You come back to our floor," which so clearly meant, *You survive this and you'll be back to recuperate.*

It struck me even more forcefully that this might really be it, the last look at my father alive. I whipped out my phone as they were wheeling him toward the second set of doors to the prep room and recorded the bed receding down the hallway and through the doors. Because the orderly pushed the bed from behind, the camera couldn't catch any of my father in it, except for a lump at the far end. His foot under the sheet.

It was so late in the evening, there was nothing much to do but wait. The hospital had a special holding area near the surgery with comfy leather chairs and couches, a TV mounted on a pillar, and magazines on every side table. Leica still had snacks we hadn't finished that afternoon. We ate cashews and sucked on skinny straws in apple juice boxes. We watched terrible TV with the sound turned off. We could have gone to a movie, because he was expected to be in there for hours, but I suspect Leica and Rolland didn't want to leave the waiting area for the same reason I didn't, which none of us wanted to say—we anticipated that a doctor would come out soon to say that Dad didn't make it.

I'd never waited for anyone during surgery before. There was an odd sense of anticipation and also relief, my first taste of it since my visits to Dad began. I had nothing to do. I didn't have to respond to any requests, invent something to talk about, try not

to drag his mood down by crying in front of him. I neither had to think nor pretend. My body sank into the chair and refused to move for hours.

There wasn't a soul in the surgery area with us. Hours passed before a man in lime green scrubs walked by, which surprised us. The halls had been so quiet. Leica turned in her chair to watch him as he passed. We all watched him.

When the door clicked shut behind him, Leica asked, "Do you think that's for Dad?"

Rolland and I shrugged.

"Don't know, Leica," he said.

"They're taking a long time. I wonder if there's complications."

My brother-in-law said we'd find out soon.

There was a pause then. Leica and I looked at each other. Then time moved us along again and another hour passed.

As those first hours went by, before the guy in scrubs came through, we'd grown more optimistic, because no news was good news. That much seemed clear to us. But after that Medical Staff Only door clicked shut, at about the four-hour mark—the surgery was longer than any of us had expected—we all became more sceptical. Each minute seemed to confirm that there were complications.

Leica turned to me and said she was starting to get worried.

"I have been for an hour," I said.

"Me too," she answered.

None of us had thought to ask how long the surgery would be. Guessing how long it would take to remove a man's leg was pretty much the epitome of bizarre.

Leica and I agreed if this was just another step down in his decline, if he was going to have to suffer like this again anytime soon, we hoped he'd die peacefully on the table. He'd be unconscious. It was a great death, compared to those that he'd near-missed.

Dad had been admitted to the hospital a couple years before and put into an induced coma to prevent him from pulling the breathing tube out of his throat. When the doctor called to tell me this, I said that Dad had a DNR (Do Not Resuscitate) form, which he'd signed from his previous stay in the hospital. Leica would know where it was, but she was intentionally off-grid in Mexico, to force herself to get some rest.

"When she's back," the doctor said, "she can bring that in, and we'll proceed according to those documents." A polite way of saying my father would be removed from the breathing tube and die. The next day, my phone rang with a call from my father's number. I suspected it was his girlfriend Rose or his brother calling to tell me the news.

"Hey, kid," my father said. It was his voice, a little more gravelly from the effects of the two days of breathing tube. I felt such a thrill hearing his voice, such a jolt, it was like the scene in *The Matrix* where something has readjusted, *blip-bam*, where everything in the room seems the same but you sense that nothing is. That moment of dread, which disappeared like dust blown off a dinner plate, made it clear beyond and beneath and above every bit of grief he had caused me that I loved him. The feeling was a surprise, especially the unmistakable clarity of it.

When the doctor finally came out of surgery in his blue

scrubs, a small cap on his head like in the movies, with a smile on his face, I felt the same sort of rush as I had when I heard my father's voice on the phone. Equal parts relief and disbelief.

"He's doing fine," the doctor said. "He did a great job in surgery. There were no complications. His heart was steady and stable. So was his breathing. We couldn't have asked for a better result."

"That's a surprise," I said.

"It was a surprise to us too, frankly. It didn't look good, the odds were poor. But," he emphasized, "his heart was steady through the whole procedure. It was excellent. He's a tough bugger. That heart refuses to quit."

The doctor told us that Dad would be out cold until noon or later because of the anaesthesia and the trauma to his body, so Leica and Rolland drove home that night. They wanted to sleep in their own bed after such a stressful two days. Rolland said he'd be fine to do an hour behind the wheel.

I logged into my Grindr account before I'd even left the hospital, but once at the Rotary Club hotel, exhaustion managed to convince me to go straight to bed.

The next morning I woke early. I always woke early, regardless of how long I did or didn't sleep. It was only eight a.m. I immediately logged into chat rooms and Grindr. I ate another apple and granola bar. I chatted and masturbated for hours and didn't leave my bed that morning.

Around noon, my sister texted to say she was at the hospital already. Where was I?

"Just getting motivated," I replied. "Didn't sleep well."

I left the hotel room without showering, in a rush, feeling like shit. My father was waking up from surgery, and I'd spent the morning in bed cruising for sex. I'd been simultaneously looking obsessively and trying hard not to follow through.

Walking across the parking lot in the crisp fall air and the sunshine, it seemed so obvious that I could have easily been there cruising online and watching over Dad while he slept. But the trick with being in a cruising mode is that you just keep thinking you're about to quit. You're going to turn it off and be responsible at any moment. Compulsive minutes do their tricky thing of turning liquid and pouring into hours.

When I phoned my best friend on the walk over to tell him what an ass I'd been, Colin said, "You're having a really hard time, Michael. Don't beat yourself up. These are extraordinary circumstances. You get to be stressed. You have every right. Just be mindful to take care of yourself within that."

"These are extraordinary circumstances," I repeated slowly.

I had barely enough brainpower to think, but I found comfort in being given permission to be overwhelmed.

Dad had a private room on a new floor for post-operative patients. He was asleep when I arrived; he hadn't woken at all yet—*thank god,* I thought. Leica didn't seem pleased that I was late, but I gave her a weak explanation that I was exhausted and couldn't get out of bed in the morning. And I had three-hour jetlag, so noon was only nine a.m. All true and not true. Leica softened. Rolland didn't say a thing.

Dad's truncated leg was moving in his sleep, raising the

sheets. About the size of a football or a fat loaf of bread, the leg looked as though it had been dropped through a hole in the mattress. It was clown-like, really. A little circus freak in the bed doing a routine under the covers.

The three of us clustered toward the end of his bed, speaking in whispers to pretend we were distracting ourselves from the obvious. But we were all staring. I felt like a sick fuck, but it was so damn fascinating. We watched the stump move like an animated watermelon rising and falling under the bed sheets. Had he been lifting his whole leg, his foot would have been four feet up in the air. But what remained was light, obviously.

The stub was unpredictable. Within thirty seconds, it went up and down, up and partway down, up again. Down again. Partway up, and it held there, then it bobbed, dipped, and rose straight up, pointing toward the ceiling. Then it dropped again. For an hour, the stump teased us under the blankets, so we couldn't forget it was there. And what was missing.

Dad woke up groggily, slowly, his eyes peeling apart like those of a newborn unaccustomed to the light. It was close to one in the afternoon. When his eyes looked open enough that we were sure he was awake, we said hello. It took another five minutes before he said hello back.

We told him how happy we were to see him, how well the doctors said he did, how he was on the other side of this, and how relieved we were. For the first time in my life, I said how proud I was of him. "You did a great job, Dad," I added. "You were super brave."

He blinked, looked at the wall, then back at me, and blinked again.

"Are there any ice chips?" he asked.

A nurse came in to check on him and was pleased he was awake. She told him to let her know if he felt anything. He shouldn't feel anything at all, so if he did, they'd give him a new dose of meds.

As the hour progressed, Dad grew a bit more restless. He winced from time to time, so that we asked if he was in pain.

"No," he said.

"Are you sure?" we asked. "The nurses said to let them know if you feel anything."

He looked at the table and asked, "What's for lunch? Did they bring me lunch?"

"Are you hungry?" my sister asked, rolling the side table over to the bed.

"I haven't eaten in *two days*," Dad said.

"Lunch is still here." Leica lifted the lid from the plate. "There's soup."

"What kind?"

"Split pea," Leica answered.

"I'll eat it," he said.

Somewhere midway through his meal, Dad began to wince again. He denied being in pain and seemed irritated to have been asked. He wanted us to stop fussing. But as we talked with him after lunch, he continued to wince and pull in air. Unmistakeable pain.

Yes, he admitted, he had some pain, but it wasn't that bad.

Rolland went to talk to the nurse immediately. When he came back, he reported that they said they'd get right on it.

When Gina the nurse arrived—young, efficient, with long blonde hair—she apologized. "His file is about a foot thick," she said, gesturing with her hands. She spoke rapidly, like someone was pressing her fast-forward button. "I have to go through all of that before I can prescribe anything. We have to know what he's been on to make sure we get it right. I wanted to let you know I'm working on it, but it's going to take a while. I need you to be patient, Mr Smith, okay? We'll get you fixed up soon."

We thanked her.

"All new patients on a floor have to have their files reviewed when they arrive on that floor. We haven't seen him before. He was on three? So now he's arrived on four we have to go through all of his history again. We don't want to make a mistake, because Mike's got enough to deal with already, don't you, Mike? Okay, I'll see you soon. As soon as I can."

She left, springing out the door in white running shoes.

Within the next twenty minutes, Dad's pain intensified. He was agitated and sighing, gripping the handrails of the bed and breathing through his teeth. Each minute was worse, until he was crazed with pain.

His eyes pooled with tears. "I thought the pain would be gone," he choked out bitterly, desperately. "They took my leg, but the pain is still here." He looked around the room, as though beside himself to find someone to blame.

"Dad, the pain is temporary," Leica said.

"But it's still here."

"It'll pass," I said. "Breathe through it."

Leica stepped to the side of the bed and took his hand. "They can get it under control. They'll *get* it under control, but you have to let them know as soon as you feel it."

"It didn't hurt before."

"Not pain, Dad," I said. "Anything. If you can feel anything, if you can even feel it a little, you're to let them know."

"I don't want to disturb anyone," he said.

"What do you mean?" I asked.

"They're busy."

"Dad, that's their job. They're paid to give you medication. They're paid to make sure you aren't in pain. That *is* their job."

He looked toward the door, then right past me, outside, toward the sky. I couldn't tell if he didn't believe me or if he was trying to.

I took another tack. "Managing your pain is one of their first priorities. It's more important than nearly everything else they're doing."

He screwed up his face. "I know," he said, "but I don't want to disturb anyone."

Like a bead of dish soap in greasy water, forty years of our relationship cleared.

My father was so self-effacing, he couldn't imagine someone cared enough to respond to his agony. He would rather have suffered than push a button to make a request. If he couldn't look after his own intense pain for fear of disrupting the person paid to do it, how could he have done any better by us? As my sister later said succinctly, "Dad didn't think he deserved to love

us." He hadn't failed me because he didn't care. He'd failed me, that was undeniable—god knows my sister and I could take a very long time counting the ways—but not for any lack of love.

Dad looked around the room without really seeing anything. His eyes weren't settling but roamed like those of a madman trying to look beyond the walls of a cell. He began to moan as the pain washed through him, and his eyes rolled back. His sounds were animal, like a bull moose baying beside the semi that struck it. The pain washed into his leg and then, briefly, receded. It had its own complicated rhythm, so that when I thought I could anticipate the next cringe it hesitated, then began again in earnest.

For the first few minutes, I did nothing. Leica and I had visited with Dad dozens of times after my mother moved us out, and all he could do was sob. In jean shorts, in his work clothes, at the stove, at the kitchen table, on the couch, at the sink peeling potatoes, standing in front of the picture window, in the driver's seat of his Ford half-ton. That first year or two, Dad wept at least once every visit he had with us. Leica and I would check in with each other before visiting to see if the other had heard from him recently, to find out how bad he was so we could either brace ourselves or choose to wait it out until he was a bit more solid. The crying jags slowly tapered off but were unpredictable—sometimes he'd be fine, and if I left quickly, I could get out of his apartment before the tears started. Often his face would crumple the moment I had my jacket on. The trick was to sound as upbeat as possible, just at the end, and scoot out with little fanfare, emanating optimism,

avoiding long goodbyes or tenderness, pretending I didn't see the tears in his eyes.

He'd been chronically depressed. The drinking didn't help. The one time we finally talked him into going to a psychiatrist, the therapist told him he could choose to not dwell on my mother, and Dad reached across the desk and put his hand over the therapist's throat, telling him nobody could ask him to forget her. He told us that story to prove his right to be disgusted with the man.

In all the years when I was too young to know what to do, too dumbfounded by the display of his weeping, too locked into the mode of relating to him that we'd established, I never once hugged him. Through all his terrors of abandonment, I never once gestured with anything more than talk. It never even occurred to me until writing this memoir that giving my weeping father a hug all those years ago might have been a smart idea. Physical comfort was not part of our vocabulary. We never touched, except occasionally when saying goodbye in the years since I'd left Cornwall for university, or when he'd been a playful bully when I was a kid, twisting my arm or thumb wrestling.

In that moment in the hospital something rose out of me, something uncommon, something new. I could hear the situation calling for me to do something. I didn't have a problem getting naked for a room of 400 people or wearing a skirt while walking down a busy street, but I had to convince myself I had permission to hold my father's hand. I talked myself through it. *Yes, you are allowed to do this. Your father lost his leg and*

this pain is exceptional and you can be the person you want to be and step forward, right foot, left foot, right foot, stand next to him, put your fingers around his, and rest his palm in your own.

So when I moved my chair closer to the bed and took Dad's hand in mine and told him to squeeze it—a Herculean effort, just realizing that I could do this—the act felt like nothing short of a stroke of genius. I coached him through the pain for a slow half hour. "Breathe, Dad," I said as his body clenched. He practically lifted clear off the bed. "Relax, let it go, let it pass, don't fight it, let the pain roll through you and out." I repeated that mantra over and again. Sometimes he squeezed my hand, sometimes he let it go. Leica, Rolland, and I went in cycles of trying this and that to see if anything would make it easier to bear the pain. Nothing did. But making the effort was necessary to fill the time until the medication came.

When Dad's cries began to interfere with his ability to catch his breath, Leica raced to the nurse's station. She returned, saying they'd be coming soon, they were moving as fast as they could.

When Dad released my hand again, Leica approached the bed. She noticed the drained look on my face, so I took the opportunity to step out too. I walked up the hall, my arms and legs vibrating. A kind of weeping was coming through my body, pouring out my fingers. I passed the end of the hall and into the small lounge with a television. There was a view of the parking lot outside, the Gatineau Hills in the distance. The sunlight was fall light, with an afternoon intensity in the yellow leaves of the trees. The room was dim. The furniture was cheap vinyl.

I sat in a chair, buried my face in my hands, and allowed myself to release. I freaked the fuck out, wept, heaved, gnashed teeth, pulled at my face, shook, and drooled snot down my upper lip.

That afternoon I would try to describe on the phone to Colin how intense this experience was, to encapsulate for myself the nature of the intensity. "It's real-life horror," I would tell him. "This is what *horror* is. Like … *filmic* horror. This is what gore films are trying to describe."

Dad was a Frankenstein, his leg making clear the freakishness of the body, the unbelievableness of surgery, of cutting open a person's skin and sawing parts off and sewing up the wound that the person simply had to endure. Our vulnerability is freakish. My father's stump leg was the blackest of jokes, ridiculous, bathetic, terrifying. I hadn't been able to stop watching it. I couldn't stop imagining the rest of the leg in an incinerator, turning to ash. The meat of it, disembodied. Its density. Its weight. The white bone and all that red interior, sliced from his body, the end of his stump sewn up with skin strategically left over. And through all of that torture, there was nothing on god's green earth that I could do to help. Except hope.

When I walked back into the room, Dad lay on his left side, holding the bedrails. My brother-in-law sat behind him on the bed. I marvelled at Rolland's hand rubbing up and down my father's back.

We don't touch like this, I thought, envious.

Soon after I returned, the nurse arrived with medication. It took another twenty minutes or so before Dad's pain dissipated. He slept for the rest of that day, so Leica and Rolland went home just before suppertime. They both had to work the next day. Always looking out for me, Leica had driven up in Dad's Pontiac. They left it for me so I'd have a vehicle in the city.

I hadn't made plans to see Ottawa friends because I knew I wouldn't be good company, and none of them were close enough that it was fair for me to be miserable or sloppy with them. I wouldn't normally call them in a crisis, I reasoned, so why would I rely on them now? It was stupid thinking—friends only become better friends when you trust them. Given my state of mind, I didn't have the wherewithal to risk it.

When I'd had a moment of downtime, I'd called one or two people in Vancouver, but what do you say when you don't even know what you're feeling? I'd check in with a new report on what had happened that day.

"This is overwhelming," I'd say. "It's so big I don't know what I'm doing." I'd zombie-talk my way through feelings. But beneath the little I could articulate, a panic trembled within me, foreign, intangible. It was like standing on a wooden bridge and feeling the tremor of the river underneath that you can't see but know to be there. When I ran out of ways to say that I didn't know what to say, I hung up the phone and logged into Grindr. If I was in my hotel room, I picked up the computer. Sometimes when friends phoned, I didn't answer because

saying the same dumb things felt worse than being alone in it. To be conscious or articulate was too much.

Later that particular afternoon, while I mindlessly chatted online, Don texted me. "How's your Dad doing? How are you?" he asked, which was likely the sweetest gesture of my cruising life. I gave him an honest answer—that it was a new kind of nightmare. I don't recall his reply, except that it was caring.

I asked how he and Adam were and Don answered they were great. "Adam had a great time," Don wrote. "So I owe you some thanks. You're a great guy." I wanted to marry them both instantly.

After we said our goodbyes, I realized that by all accounts, my night with them had been a success. I'd gone cruising when I could have been sleeping, but within that experience I'd been forthright about my emotional life and it had served me well. These guys were respectful. *Don't ruin it,* I told myself. *Let that hookup be enough.* But immediately I went back online.

I desperately tried not to follow through, not to act out, not to bareback, not to contract HIV, not to confirm my sense of ironic fatalism that said while visiting my dying father would be a classic time to get infected, a perfect storm.

Nobody was biting that afternoon—I couldn't find anyone who wanted to come to the hotel and everyone I did talk to couldn't host. I went back to the hospital around dinnertime, but Dad slept for the rest of the evening. I alternated between answering work emails and cruising until it was approaching ten p.m. Still nobody was able to travel. I decided to drive the Pontiac to a bathhouse I'd read about online. Even though the

sign on the doors said it was open for another three hours, the bathhouse door was locked shut.

I went back to the hotel, took a shower, and slept.

The next morning, I woke with my alarm, which I'd set for just before nine a.m., visiting hours. I had about five hours of sleep. I ate my last apple and granola bar for breakfast. I skipped a shower—I was less likely to cruise later in the day if I was dirty. I knew these choices put me at risk: my cruising was worse if I didn't take care of myself. When my blood sugar was low, when I hadn't slept enough, when I felt poorly about myself, I was more likely to be compulsive.

Dad was awake when I arrived. He was chipper—*chipper!*—and said, "Well, good day, Sonny-boy," like I'd dropped in unexpectedly.

I asked how his night was.

"Not great. I was up about midnight and cried all night," he said, his voice dropping, "but nobody heard me. I didn't disturb anyone."

"Fuck, Dad," I said. "You could have bawled all night and woken the whole floor. Nobody would blame you."

"It was fine," he said. "I didn't want to disturb anyone. It's not my place. But I'm better this morning." His face was lit and bright-eyed.

That afternoon Dad was going for dialysis, which meant he'd be gone until suppertime. It took more than four hours to clear out his blood. After our morning visit, we arranged for me to come back at five p.m.

He hadn't eaten a supper in three days, so I said I'd get him anything he wanted. "Chinese," he said decisively.

"Okay," I said, chuckling. "I think I'll get Chinese."

"Good man," Dad said.

After they wheeled him out of the room for dialysis, I returned to the hotel, avoiding the woman at the desk who'd been sweetly asking me how my dad was doing, how I was doing. I didn't want to say the same things as the morning before and that evening. In my room, I lounged across the bed, plumped two pillows under me, and tried to nap.

I lasted about two minutes.

My gut was wired. My foot jiggled like the tail of a rattlesnake. I wanted to disappear. *Try marking*, I thought. *Do some work.* But the mind wanted distraction. It was so speedy, I could barely think. It was like my body was racing so fast in place that I could barely catch a breath.

I picked up the computer and logged onto my cruising websites. I opened two apps on my phone and signed in. Despite reminding myself that I'd cruised already this visit, that I'd been successful with a threesome, that I could leave it at that, within a half hour I invited someone to come over to make out.

After we'd signed off and he was on his way, I began tidying a bit, just throwing dirty clothes into the side pocket of my luggage, picking up my wallet and hiding it among my books. In the midst of this, I realized I couldn't recall what this guy looked like. Who was coming over?

I checked our message history on my computer and his

profile, and sure enough, I'd chatted with so many different guys I'd lost track and invited someone over without a clue what he looked like. He had no stats listed, so I hadn't any information about his age, weight, or height. Any man could knock on that door, and I wouldn't know if he was a concierge or a trick.

The man who showed up was a big guy, about twice my weight, white-haired, and a little sweaty and panting either from walking up the flight of stairs or being nervous. He looked like a friendly small-town cop about to retire, from an episode of *Murder, She Wrote*. Harmless, maybe bumbling, and friendly. He did not fall into my very large category of hot.

I invited him in immediately because I didn't want anyone to hear me in the hall turning down a trick. As the door closed, he introduced himself as Bill. We shook hands. He took his shoes off.

I didn't know how to tell him that I wasn't interested in fooling around. If he left, chances were I'd find myself online all over again. There likely wasn't enough time to find another guy, and if he left, I'd be alone in my room. I really wanted the distraction.

The table and chairs hadn't been totally cleared, because after realizing I'd invited a total *inconnu* over, I had lain on the bed shaking my foot in stressed-out anticipation, so Bill helped himself to the bed. He lay back against the pillows. I sat next to him, looking at the painted cinderblock wall.

We chitchatted about where I had travelled from and how long I was in town. He must have guessed I was here for

something medical, because why else would I be staying at the Rotary Club hotel next to the hospital? But he didn't ask.

He turned on his side, put his arm over my waist, and kissed me. I was not at all interested—the machine of my addiction hadn't turned on, even that was shut down—so I barely kissed him back. My regular mind talked away in my head trying to figure out how best to vacate this situation. I decided to tell him the whole truth. I explained that my father had lost his leg. I told him that I was sorry he'd come all this way but I wasn't making good decisions, that I was compulsive because of the stress, and I wasn't in the mood to fool around. This wasn't a healthy decision. Then, without warning, I wept.

Bill reached his large arm around my shoulder and pulled me into a hug. "That's okay," he said. "You cry all you want. Let it all out."

With his arm around me, and the stubble from his cheek against the top of my head, I smelled his sweat and laundry soap. His padded palm cupped the back of my head. I could tell I was soaking the pillow and the cotton collar of his shirt, but I surprised myself by weeping as hard as I wanted to. *I'm having a real moment,* I told myself. *Cruising can be fixed by being honest in the moment.*

When I'd cried myself out, I apologized to Bill.

"That's just fine. Sometimes you need a hug, right? You're having a hard time." He ran a hand up and down the length of my hip. "You know what you need? Some stress release. A blowjob will help."

"I don't think I'm up for it, Bill. I'm sorry."

"You'll feel a lot better," he said, his hand slipping to the inside of my thigh. "Just relax and close your eyes." His hand pushed gently on my hip, to roll me onto my back.

"I don't think so, Bill."

"That's fine," he said, his tone acknowledging he knew I wasn't interested. "You just have to lay there and relax. You don't have to do anything."

His left hand undid the button of my jeans, then unzipped them.

Bill and I knew that this is how loneliness works. You don't care that the man doesn't find you attractive, because you want the comfort that comes from the heat of his body. You get validation in being able to touch him, regardless of how you managed to arrange it. If you manoeuvre your hands onto his genitals, it's the warmth from his skin that matters. The transgression of what steps it took to get his pants down is partly the cause of your arousal, and the comfort in that arousal makes your actions justified.

We construct these ethical mind games because our loneliness drives us forward in a desperation so acute we are rendered unfeeling, until the moment the heat of someone else's skin warms our own, and we can immerse ourselves in the sensuality of their flesh. We are alive in their responses; each sigh they make proves us right, each groan is proof we matter. In the moment.

I knew what Bill was doing, so I let him do it. Closing my eyes and using the discomfort of the micro-aggressive dynamic to arouse me was easier than trying to get him out of the hotel

room without hurting his feelings, without invalidating him, without having to negotiate an emotional confrontation or finding the right words, without putting me at risk of simply finding someone else to come over, when I hadn't the time to do so.

That evening, I was about half an hour late for supper. I'd found a Chinese restaurant not far from the hospital. It was perfect greasy-spoon Canadian-Chinese food.

When I walked in to Dad's hospital room, I apologized for being late. I lied and said that the take-out had a longer wait than I'd expected.

"No worries," Dad said. He wasn't as chipper as in the morning but still surprisingly alert.

When I asked how dialysis was, he said, "I spent the afternoon with my leg. When nobody was there, I touched it. I hadn't even looked at it yet. Not really. But I touched it all over. *Okay. Okay, this is it*, I thought." His tone changed, explaining to me, "This isn't what's left of my leg." His hands gestured to either side of the stump. "This *is* my leg."

Dad ate more of his supper than I did, even though I was starving. After three days with barely any food, he nearly licked the paper take-out containers. The visit was relaxed and surprising. Dad was calm, even jovial. He seemed steadier than I'd seen him in all these months. He was recognizable, his face more like his face. On the other side of his surgery, I realized that he'd never been sober for more than a few weeks at best, and here he'd been in the hospital without a drink for eight months.

We didn't visit for more than a couple hours before Dad was exhausted and wanted to sleep. He'd been up most of the night before. I was leaving early the next morning, so this was our goodbye.

I wish I could say I remember it, but I don't. We had so many goodbyes in hospital rooms from night to night and visit to visit that I can't recall this one. It was just another goodbye.

A FAILED MAN

TWO MONTHS LATER, on the evening of November 28, I was driving my teaching assistant home from our class. It was our last of the semester. We crawled through traffic because a Junior A hockey game had just ended; the downtown streets were flooded as folks left the arena.

My cell phone rang from an unknown number with the Ottawa area code. It was 9:27 p.m., after midnight there. I picked up, despite being behind the wheel, and put the caller on speakerphone.

It was a nurse at the hospital. I recognized his voice; he was a Caribbean man I remembered from my last visit.

He asked if I was busy. I told him I was driving.

"I'll call back," he said, "when you're done driving. How long will you be?"

I told him I was stuck in a traffic jam; I was close to home.

I didn't want him to hang up; I suspected what this call was. "Can I just ask: has my father died?"

"I should call you back in a few minutes," he repeated.

"I'm on speakerphone," I said. "I'm stuck in traffic, not driving. You can tell me."

"Yes," he said, "your father passed away a few moments ago. I'm very sorry for your loss."

He'd tried to telephone my sister, he said, but nobody had answered her phone. I was the second contact on the list. It was the first time they'd ever had to call me—Leica had always answered before.

My father died like this, without fanfare. There were no trumpets, no grand gestures. When it happened, despite all that had occurred before, death seemed to come without warning. My insides began to vibrate. I was stuck in my car staring at taillights. My student was silent in the seat beside me.

The nurse told me Dad had asphyxiated. "I was right there, walking past his room when I saw he was having trouble. We tried to help him, but we couldn't relieve the blockage in time."

After all the illnesses and near-death experiences, Dad had choked to death.

I was only four blocks from home and nearly outside my grad student's place, but traffic wasn't moving. I parked the car and reassured my student I was fine so she could walk home, then called my sister.

She answered on the fourth ring, her voice small and distant. I'd woken her.

"Leica," I said. "I'm sorry to say I have bad news." I tried to think of how to brace her for what was to come next. "This is the call we've been dreading," I said. "The hospital called. Dad's died."

"What?" she asked, her voice rising, still small and far away. "What do you mean?"

"The nurse phoned just now. He choked to death."

"Why did they phone you?" she asked, puzzled.

"Nobody answered your phone. I was next on their list."

"They have my cell. It's downstairs."

"I'm so sorry, Leica," I said. My voice was cracking.

"Am I dreaming?" she asked. "Am I dreaming?" There was panic in her voice. I'd never heard her so high-pitched. "Tell me I'm dreaming. Is this a nightmare?" she asked.

"This isn't a dream, Leica. I'm sorry."

I heard her say, "Rolland, Rolland, Dad's died. Wake up. Dad is dead."

Then she sobbed and sobbed and sobbed on the phone with me.

I flew to Ottawa the next afternoon with my black suit. We had about four days, I think, to prepare for the funeral, during which we visited the funeral home to secure arrangements for Dad's cremation, met with the priest at the church, Photoshopped an image of him for the funeral home, and a few days later picked up his ashes, which were much heavier than I expected, about the weight of a mid-sized pumpkin.

The morning we arrived at the church for the funeral, the framed photo of Dad was on a small table with the urn, a cherrywood box. The table looked empty. We realized that we hadn't thought about flowers. Luckily, Dad's ex-partner had sent mums to the church, so we placed those behind the urn and photo.

When Dad's first three brothers arrived, they each shook my hand, which caught me off-guard. My father was dead, their brother, and they only wanted to shake hands? I was practically reeling with disappointment that even at their brother's death, my uncles could afford only the slightest sign of affection.

My uncle Pat sat a third of the way back. My uncle Larry was even further behind him. Other than Leica and her kids, his brothers were the closest family Dad had, and they were sitting like strangers in the large church. There weren't more than fifty people at his service, half of whom I didn't recognize. Why wouldn't his brothers sit at the front of the church? With distance, I can surmise that they were too much like my father, too self-effacing and terrified to be on display. They probably didn't know that it was expected of them or that it might be important for Leica and me to have them up there with us.

The last uncle to arrive was Ted, who hugged me hello. I was so grateful for the tenderness I nearly sobbed. I asked if he and his family would sit at the front so it wasn't empty. They agreed. Every small act felt like a huge gesture of generosity.

When the time came for the eulogy, I approached the pulpit. I'd been clear with myself that I wanted to tell the story of my father as I knew him, without sugar-coating. Leica had heard it beforehand and loved it, but I feared the brothers might resent me if I said anything critical. I had no idea what they might think.

Looking out at the forty or so guests scattered amongst the forty rows of pews, the church felt too empty. My sister sat in the front row, with our mother right behind her. Rose was in

the pew behind them, on the other side of the church, with her daughter. The brothers weren't sitting together.

The world felt very large at that moment, standing with the pulpit in front of me, my hands on the wood frame holding my neat white papers. The world was terrifically expansive and unknowable, and this moment was much too small, much too everyday. I should have been burning, aflame. I should have been twenty feet tall. We should all have been weeping on the floor of the church. I wanted my uncles to explode into tears. I wanted the doors to fly open and my father to walk in on a cushion of air, aglow, and invite me to speak in his favour.

This is all I said:

> I wanted to speak today at my father's service because, as a writer, it's a way I know to honour the things of the world I love.
>
> Let it be known that I loved my father.
>
> My favourite story of Dad took place at Chez Louise, where he used to drink and play pool on their one table. One day, Dad watched a young guy hog the pool table all afternoon. Men would come in wanting to play together, but this kid kept winning and refused to take his name off the chalkboard, so everyone had to play him, instead of getting in a round with each other.
>
> Eventually, Dad had had enough; he put his name on the board and played this guy. Now Dad always left a long pause after this line. He loved to tell a story in pieces, with cliff-hangers everywhere, so that you had to ask

him questions to find out what happened. "So … was he any good?" I asked him, and Dad answered, "Not good enough."

Here are a few things I know about my father:

That he liked the Toronto Maple Leafs and not the Montreal Canadiens (though he *used to* like the Montreal Canadiens).

That in the '70s his friends from the CB club called him Dirty Ernie.

That the last time he took me fishing was for a work derby at Columbia, and I caught the biggest perch and won a rod and reel, but he didn't catch a thing—it's just coincidence we never fished together again.

That maybe the fish I caught at his derby wasn't a perch, and Dad would know. It's the kind of thing he'd remember.

That he was a great worker and a darn good shop steward, because he believed in fairness and honesty and doing a job well.

That he drank too much and threw up once in our all-white Monte Carlo.

That one winter he gave his warm coat away to someone who needed it more than he.

That he loved me, that he loved my sister Leica and my brother-in-law Rolland, that he loved his granddaughter Natasha and grandson Nathan, that he loved my mother, and he loved Rose and her family, that he missed his parents, but especially his own mother, he missed her most of all, and that he loved his brothers, all four of them.

That one time when a plate of his dentures were broken, he met an undertaker in a bar, both of them drinking, until they went back to the funeral home so Dad could try on old dentures that the undertaker had collected in a bucket. None of them fit properly.

That the night after he lost his leg, he cried alone in the hospital room until he couldn't cry anymore, but nobody heard him, he said; he didn't want to disturb anyone.

The poet Ted Hughes, in a now-famous letter to his son, said that your vulnerability is like a child inside you, it needs nurturing and mentoring, it needs to be let out to enjoy the sun. He finishes that letter by saying: "The only calibration that counts is how much heart people invest, how much they ignore their fears of being hurt or caught out or humiliated. And the only thing people regret is that they didn't live boldly enough, that they didn't invest enough heart, didn't love enough. Nothing else really counts at all."

I know my father didn't let love in, didn't trust himself, or others, didn't feel safe enough to put down his armour very often. He said as much to my sister in these last weeks, that he kept his distance on purpose, which was a mistake of his own judgment, from his own fears. I know his heart was fierce and unwieldy. He had a rich interior life, so much so that he didn't know how to handle it, what to do with it, where to put that fear and love he felt for the world. So he poured it into a cold glass and drank it down, day by day. Love is a sickness if you don't share it.

I have great comfort knowing my father is free from those worries, knowing he is free to love us in the manner he wished he could while he was alive, knowing he is free to be the man he wished he could be. In these last months he has loved us better than he was able to before: he let us in when he was terrified in the hospital, and suffering with pain, and you can't imagine what a gift his openness was to me. I am profoundly grateful—and changed—by that. Through his struggle I came to know my father as the hero I had wished him to be, not for his strength, nor his courage, nor by any test of manhood, but because of his willingness to be vulnerable. Because he admitted to that terror … and then let me hold his hand as some company through it.

Dad didn't text me often in his final months, and rarely without prompting, but he sent me a final note last week, out of the blue, which I think gives a great insight into what kind of man he was: ever the smart aleck.

Our exchange went like this:

"Hi, Mick, are you still upset over the closing of the Twinkie factory?"

I answered, "Ha ha, you're hysterical, you old bugger. You doing well? I'm still hunting for a ticket for Xmas."

He replied, "I heard you want to get a job running the factory where they are made."

"I'm gonna knock yer lights out," I wrote.

"I ain't got any lights left," he said. "They are all burnt out."

"Ha ha. You're cheeky today. Love it. I'm still chuckling about Twinkies."

"Well, I know how much they meant to you," he replied, "so cry if you like."

After the funeral, Leica, Rolland, my niece, nephew, and I stood in a receiving line in the side room for the reception. We shook the hand of everyone who passed. In the lineup, I saw Gerry, Dad's old friend who'd lost his leg to a train.

When it was his turn in line, Gerry gripped my hand and shook it. "It was a bass," he said.

"A bass?" I asked. "Were you there?"

"It was my boat," he said. "And you caught a six-pound bass."

In the summer, I asked my uncles if we could meet when I was in Ontario to talk about Dad, for research into this book. I wanted to ask the boys what kind of man they thought my father was.

Leica arranged for us to have a meeting with my uncle Pat in the afternoon and the other three agreed to a barbecue at my uncle Bob's place afterward (because two of my uncles didn't want to meet formally; they didn't want to talk much about Dad or growing up). Pat wasn't invited to the barbecue; he'd had so many drunken conflicts with his brothers over the years, they didn't see much of him, even though they all lived in a town of 2,000 people.

The most interesting thing about our visit with Pat was how freakishly he looked like my father. They always resembled each

other, but when I knew I'd never see my father's face again, and here it was, somewhat translated into the genes of his brother, it created a kind of longing in my blood. My body ached for him to be kind to us. I remember wishing we could spy on him for a day, without him knowing, to see a man who could be my father moving through the world.

At the barbecue that afternoon, I was awkward. Leica tried to help by pressing the point that we were here so I could ask questions, but I kept feeling that I didn't know these men well enough to feel I had any right to an intimacy with them. All these years, I realized, I'd seen them filtered through my father. It felt like this was the first time I'd seen them without that veil.

Soon after I got there, my uncle Larry said, looking at me, "I don't know what I can tell you. You knew him better than I did."

I wanted to scoff and say, "I barely knew him at all," but the matter-of-fact conviction in his voice said he thought it was true. He wasn't just putting me off.

I think I answered, "I don't know if that's true," and he replied with something like, "I'm sure it is."

My uncle Bob said the same thing, later in the day. "I didn't know your father very well. He was a lot older than me. He was nearly moved out by the time I was born." Bob is seven years younger than my father. I didn't understand how seven years could make a difference until later the brothers told me that when Dad was twelve, he was sent off to a farm to work for the summers. All the boys had to pay room and board to my grandfather from the age of twelve onwards, except Bob, the youngest. The other boys had worn my grandfather down by then.

If we do the math, Bob was only five when Dad started leaving for the summers. My father also had a job in the grocery store in town during the school year. Twelve is the age at which Dad started smoking. He was living a mostly independent life by then, paying rent and board, buying his own clothes, working year-round.

When the day started to wind to a close—most of the cousins had left and the aunts and uncles had moved inside, sitting around the table so my aunt Debbie could put things away in the kitchen—Leica insisted we talk.

She put her hands on the table. "Mick wanted to ask you questions before you left," she said to everyone. "He can tell you more what he wants to talk about."

I explained that I was working on a book about my relationship to masculinity, which also meant my relationship with my father. I thought that they might have some insights into Dad; they might have some stories they wanted to share.

Ted asked about our afternoon with Uncle Pat. "What did Pat talk about?"

We told him a few of the stories that were new to us, nothing exciting.

Ted hadn't taken his eyes off of us. "Did he tell you about how your father had been abused?"

"No," my sister said.

I asked, "What does that mean?"

"Apparently, your dad was sexually abused by a young guy who was older than him by a few years." Ted glanced at Uncle Bob. "Did you know this?"

Bob hadn't heard about it, but Ted's second wife had, from her sister, who'd been with Pat for more than a decade before finally leaving him. (Yes, brothers married sisters, both men choosing them as their second wives.)

"What ages were they?" I asked.

"Your father was about twelve," Ted scratched at the back of his head, thinking, "so the other kid must have been about fifteen. He was older than us."

"You know who it was?"

"Yeah, we grew up with him."

"What was his name?"

"T— W—."

I wanted to look at my sister or take her hand, but I couldn't move. I didn't want to break my attention to Uncle Ted. I thought if I studied him hard enough I could decipher more of the facts from what he was saying.

"How does Pat know that Dad was abused?"

"Apparently, he walked in on them. I'm not surprised he didn't mention it to you. He showed up at my place one night, years ago, totally tight; he could barely stand. He wanted my gun, he said. He was shouting that he was going to kill the guy."

We knew from the family stories that anything you heard from Uncle Pat was difficult to believe. He used the same kind of creative convenience that my father did: there was a seed of truth in what he said, but the details that sprouted from it could change based on the situation at hand. Pat, for example, told us that afternoon that his son Brandon had been thrown in jail for a time because he beat up his girlfriend. Pat didn't

speak to his son now, because, he said, "We don't put up with that in our family. That's not who we are."

Everyone at the barbecue had laughed when we'd related that part of the conversation. "Brandon learned that from his dad," Ted had said.

Lynn had nodded her head. "He beat on Fay a bunch of times."

But this wasn't the same. Men like Pat don't admit to witnessing sexual abuse when they're sober. Their egos can't handle it even when they're drunk.

"What happened to the guy? Was he ever arrested?"

"He's still in Madoc," Ted said. "I hear about him because of business I do there."

"He's alive?"

"Oh yeah, he's alive," Ted said.

My first thought was to find this guy.

In the weeks following, I ran a variety of scenarios through my head in which I met up with him, but each encounter ended the same way: with me wondering how much of the story was true. It was clear, anyhow, this wasn't the sort of topic I could have ever broached with my father. Neither was it the sort of thing Ted would have told me while Dad was alive.

Leica and I drove home that evening, piecing together what we'd heard from the uncles. Dad was fending for himself at the age of twelve. Dad might have been, likely had been sexually abused. Dad went to his grave without ever mentioning it to us.

There was nowhere to put that information to make it sit

comfortably. We could only do what we'd done so often in our lives with my father: we held it with some compassion and hoped it wouldn't be painful in the days ahead.

The biggest irony for me is how that little piece of information about my father confirms something I teach my students year after year. The famous script editor Robert McKee describes how a classic story device offers a little detail at the climax that causes you to reframe everything you've assumed through the course of the action, so that at the end you travel back through the story and know it all differently.

When I think through my understanding of my father and his relationship to me in light of Ted's news, so much seems to fall in line for me, like locks in a tumbler clicking into place. That my father rarely touched me, that he could barely speak about the gay parts of my life, that he was ashamed to be vulnerable, and that he was desperately lonely, all made more sense now. Certainly it's too tidy to pin my father's relationship with me on any one detail, but that isn't to say the echo of my father's life doesn't now seem clearer. I'd wept on many occasions throughout my father's life wishing his days could have been easier. He suffered because the world isn't fair. I'm sure in part he suffered in the shell of his masculinity, which he thought protected him, but it was his silent prison too.

It's no wonder I came to masculinity from the opposite direction, skipping gaily through a hairy femininity, when the father I had was a man fraught with collapse. It's no wonder I considered myself a failed man: I was offered either this

perversely limited life within a prideful blue-collar masculinity, or I could be a sissy fag judged poorly by comparison. Either choice seemed embroiled with complications and self-loathing. Nobody can live such a caged life and be happy.

I thank the stars I was lucky enough to sense I didn't want that kind of masculinity for myself. At a young age, I somehow intuited that, in rejecting my father's version of manhood for one of my own devising, I was making a better trade. Still, I spent years judging that version by the old standards. The failing is not in all masculinities, I know, but it is in many of them.

After Dad had drunk himself into the hospital a few years ago, I felt some new magic, some evolution from the confluence of talking to my therapist about my father's collapse and writing this book, and it occurred to me that perhaps my being a failed man was worth celebrating. Being a failed man was a measure of my success.

It took Dad a lifetime to get sober. It took him just as long to be vulnerable enough to let Leica and me into his life so we might help him in his suffering, and even so he went to his grave with secrets no one should have to bear.

Perhaps my father's silence and distance had some influence on the eagerness I've felt as an adult to bare all. There was so much unsaid in my family, I've spent my creative life speaking up.

These last few years since my father's death, I've never felt more masculine, partly because I've settled into a gender that, if it's not of my own making, is at least of my own choosing. Life is richer each day, from the effort of putting into practice

my therapist's advice to pay attention: the more I practice listening, the more it widens the space for silence. The more silence, the more room to listen.

Six months after Dad's death, I met a handsome furry man from Québec who has become as much an accomplice as a partner. We met via a cruising app on one of the days when I was advertising my personality rather than my body or sex stats. He was drawn in by the canoe and the lake swimming. Every day he is teaching me that the body I have now is one I can love as well as he does. The last two years have been happy ones.

For every book written there are two stories. Every book has a shadow. There is the one in your hands and the one I had intended to write. The book I wanted to write was an angry finger-wag at the world, telling most men how to behave, showing them how to live by counterexample, and offering a whole lot of advice and judgment about what fuckups they have been.

Late as late can be in the process of writing, when I thought the book was a loss because it didn't do enough of those things, I realized the story I had written was a personal one, not about do's and don'ts, not about being superior in my gender choices and free to fuck up in my sexual (mis-)adventures, but an intimate walk through my days as a perhaps unusual man, a testament to the degrees one will go to in trying to fill a well of abandonment, and a vulnerable confession about how my complicated relationship to my body helped shape me.

As much as I've moved forward, I still feel Dad's hand at work in my life. He lives on in my body. He's here in my unsettled

stomach, like a nervous bell sounding the alarm. He's here in the addict's whisper, calling me to drink in the back bar where nobody will know me to ask questions. He's here in the shame I've felt for wishing I weren't alone, for wanting someone to hold me, for being weak and frightened. He's here in new disappointments as my body ages, growing more fat on my abs than muscle. He's here in the parts of me that still feel shame for not being a better man.

My father is also a gift, even in the ways he was a negative role model. Most obviously, he's here in the masculinity I set aside and the one I adopted instead. He's here in my sobriety. Here in therapy. Here in the steps I take to speak a truth that was far more hard-won than it is embarrassing.

My father lives in our hospital experience, where we practiced how to be a father and son. He is here in the risks we took, here in a trust we found together beyond our disappointments, here in the reward from letting each other in.

My father is here in the depth to which I have feared the world, which goes hand-in-hand with how I have loved it. He's here in my innocence, which is his innocence too.

ACKNOWLEDGMENTS

IT TAKES A COMMUNITY to raise a man. Thanks to my personal heroes who continue to shape a better world: Treena Chambers, Dana Baitz, Shauna Lancit Baitz, Amber Dawn, John Downes, lisa g, David Greenshields, Trish Kelly, Kim Kinakin, Francis Langevin, Patrick Martone, Billeh Nickerson, Lloyd Pritchard (Darlene the Ambassador's Wife), Matt Rader, Gary Saulnier, Zena Sharman, Colin Thomas, and my excellently confabulated Radical Faerie community who meet twice a year at Breitenbush Hot Springs.

This book had great feedback from the wonderful likes of these wonderful people: Colin Thomas, Matt Rader, and Zena Sharman. Thank you for your timely wisdoms.

I want to thank my family—who grew into such excellent adults—for loving me so well. I hope you haven't read this book, but if you have, my next wish is that you've found some kind of comfort in it, as I have in writing it.

Nobody could imagine a better best friend, brain-stormer,

editor, and surrogate father than Colin Thomas. Thank you for helping raise me with your excellent breadth of manhood.

Thank you to the University of British Columbia, Okanagan Campus, and Dean Wisdom Tettey, for their ongoing support. Much of this book was written during sabbatical. As our universities are being turned into machines for big business and profit, I call on our colleagues to speak up against the deterioration of inquiry, independent thought, and diversity. Special thanks to my colleagues in the very queer(-friendly) Faculty of Creative and Critical Studies, most especially Neil Cadger, Connie Crompton, Nancy Holmes, and Denise Kenney, for their excellent support and friendship.

Some of this writing has been previously published in other forms. I'd like to thank the following publications, and their publishers and editors, for supporting this work: *Persistence: All Ways Butch and Femme*, edited by Ivan E. Coyote and Zena Sharman (Arsenal Pulp Press); *The Love That Dare Not Speak Its Name: Essays on Queer Sexuality and Desire*, edited by Greg Wharton (Boheme Press); and *Xtra! West*, which published *Blush*, a monthly column on my misadventures.

Twenty years ago I met Brian Lam briefly at a book fair in Toronto's Convention Centre where he presented a small table of excellent queer books he'd published. I've wanted a book with Arsenal Pulp Press ever since. Thank you to Brian, Robert Ballantyne, Susan Safyan, Gerilee McBride, Cynara Geissler, and everyone at Arsenal Pulp Press for making that young fag's dream come so wonderfully true.

PHOTO: David Ellingsen

MICHAEL V. SMITH won the inaugural Dayne Ogilvie Prize
for Emerging LGBT Writers from the Writers Trust of
Canada for his first novel, *Cumberland*. He's since published
two poetry books and a second novel, *Progress*. An improv
comic, filmmaker, drag queen, and occasional clown,
Smith investigates notions of community and belonging,
especially as relating to sexuality, gender, class, and identity.
He teaches creative writing in the Faculty of Creative
and Critical Studies at University of British Columbia's
Okanagan campus in Kelowna, BC.

michaelvsmith.com